ANN MANIE MA

Mixed Messages
THE VERSATILITY OF COLLAGE

A & C BLACK · LONDON

First published in Great Britain 2012
A&C Black Publishers
an imprint of Bloomsbury Publishing Plc
50 Bedford Square
London
WC1B 3DP

ISBN: 9781408130704

A CIP catalogue record for this book is available
from the British Library

Publisher: Susan James
Project editor: Davida Saunders
Page design: Bianca Ng
Cover design: James Watson
Copy editor: Julian Beecroft

This book is produced using paper that is made
from wood grown in managed, sustainable
forests. It is natural, renewable and recyclable.
The logging and manufacturing processes conform
to the environmental regulations of the country
of origin.

Printed and bound in China

Front cover images

Centre left: *Under Construction* (detail), Fatma
Saifan, 2009 (see p.75); below left: *Lychees and
Broken Plate* (detail), Ann Manie, 2001 (see p.58);
above right: *Louvres* (detail), Ann Manie, 1988
(see p.57); centre right: *The Shroud* (detail), Hanaa
Malallah, 2009 (see p.55); below right: *Home*
(detail), Tamsyn Williams, 2010 (see p.80).

Back cover images

Above: *Vampire Cat*, Angela Rudge-Litten, 1985 (see
p.71); centre: *Crushed Paper* (detail), Ann Manie,
1987 (see p.61); below: *Battersea Park Adventure
Playground 3* (detail), Ann Manie, 1992 (see p.59).

Mixed Messages

THE VERSATILITY OF COLLAGE

CONTENTS

6 Acknowledgments
7 Author's Preface

9 PART ONE: A BRIEF HISTORICAL OUTLINE

29 PART TWO: A SELECTION OF CONTEMPORARY COLLAGE ARTISTS

83 PART THREE: INTRODUCING MATERIALS AND TECHNIQUES

107 PART FOUR: PROJECTS

120 The Inclusiveness of Collage
121 Endnotes
121 Suppliers of Art Materials
122 Glossary
127 Bibliography
128 Index

ACKNOWLEDGEMENTS

I would like to thank many people for their contribution in making this book happen. Firstly, my husband, Barry, for his observations and advice on the text, his photographic and computer skills and, above all, his unwavering patience and kindness (thank you, Binkie!!); the publishers A&C Black, for recognising the importance of collage and commissioning this book; the Trustees of the Sandra Blow Estate, for their generosity in allowing reproduction of her work in this book for free; the artist and poet Bob Devereux of the Salt House Gallery (which, sadly, recently closed), for introducing me to Anthony Frost and Roy Ray; Jason Hicklin, for his invaluable input into Part Three; and Dr Christa Paula, art historian and curator, and Janet Rady, both of whom helped me to make contact with collage artists from Iran, Iraq and Jerusalem.

The biggest acknowledgement, though, must go to the 15 artists who contributed work for Part Two. The diversity of their collages shows that this medium is alive and thriving across the globe! Extra very special thanks to these artists for their agreement to allowing the images of their work to be reproduced in this book for free.

Thanks, too, go to DACS for their assistance with obtaining the copyright licences for the images in Part One, which are referenced individually in the text; to Yale University Art Gallery for permission to reproduce *Still Life: Glass and Siphon* by Boccioni; Tate Images for the images of *The Art Critic* by Raoul Hausmann, *Still Life* by Picasso and the image from *Ten Collages from BUNK, Real Gold* by Paolozzi; the Sprengel Museum Hannover, for the image of the *Physiomythological Diluvian Picture* by Max Ernst & Hans Arp; the Bridgeman Art Library, for *Just What is it That Makes Today's Homes So Different, So Appealing?* by Richard Hamilton; and the San Francisco Museum of Modern Art (SFMOMA) for the image of *Collection* by Robert Rauschenberg.

AUTHOR'S PREFACE

The aim of this book is to introduce a wide range of people to the diverse and versatile nature of the artistic medium of collage. Through a brief explanation of the history of the use and development of collage, the showcasing of a number of contemporary artists working with this medium, and several project-based demonstrations, it will endeavour to enlighten, delight, inspire and intrigue.

I have met many people in recent years from a variety of different backgrounds who have evolved into enthusiastic collectors of collage artwork, and my hope is that the beginner, experienced amateur, art student, teacher, professional artist and collector could all find this book of interest to them. Even those with no previous knowledge of collage may feel encouraged to read some more about it and perhaps try it or collect it?

I am particularly thrilled by the inclusion of work by a variety of practising artists from different countries, cultures and backgrounds, and the insight they have given into their motivation for using collage and the various techniques that they employ.

PART ONE: A BRIEF HISTORICAL OUTLINE

The activity of collage can be described as 'an art form in which compositions are made out of pieces of paper, cloth, photographs and other miscellaneous objects, juxtaposed and pasted on a dry ground'.[1] However, taking a wider view, collage is commonly regarded as something that is fixed to something else. In relation to artistic activity it can be work that is in 'both two and three dimensions such as embroidery, appliqué, assemblage, furniture, clothing ...'.[2]

1

CUBISM

As an artistic medium, collage is relatively modern, barely 100 years old. The earliest and most famous collages were those produced in the Cubist style by Pablo Picasso and Georges Braque around 1911. These two artists, as well as others at the time, were exploring and experimenting with new methods of creating art on the two-dimensional surface of the picture plane. This creative struggle led to the style known as Cubism, whereby recognisable images of objects and people and the space they occupy are broken and fragmented into multifaceted shapes that interlock and overlap within each other. In a classic Cubist painting it is as if everything in the picture has been observed and drawn from multiple viewpoints; the traditional horizon line to describe space and proportion has been abandoned; objects and their surrounding space seem to hover in possibly deep or possibly shallow space. The viewer is presented with a sensation of ambiguity and instability. The abundance of lines and blocks of colour created an overall sense of straight-line geometry which led the French art critic Louis Vauxcelles to coin the term 'Cubism'.

The notion that a painting had to be a recognisable representation of the three-dimensional world was being questioned by the Cubist artists. Traditional techniques and methods of depicting perspective, proportion and volumes that had been used since the Italian Renaissance were being challenged. Why should a picture have a fixed horizon line drawn across the middle to upper part of the image and why should shapes and lines converge toward this line? Why should there be carefully shaded tones to represent objects, buildings and figures that become lighter as they recede towards the horizon line? Why should there be accurate measuring of proportion?

Added to this was the challenge in choice of materials. A picture need not be executed solely in a single medium, so why not use a variety of materials and processes? Pablo Picasso and Georges Braque were defying established artistic conventions not only in applying the revolutionary pictorial techniques of Cubism but also in their choice of materials: paint, pencil, crayons, charcoal, glued paper and other artefacts such as pieces of wood and fringes from soft furnishings could all appear in a single picture. So numerous and diverse were the materials used in these pictures that two-dimensional works were evolving into three-dimensional reliefs.

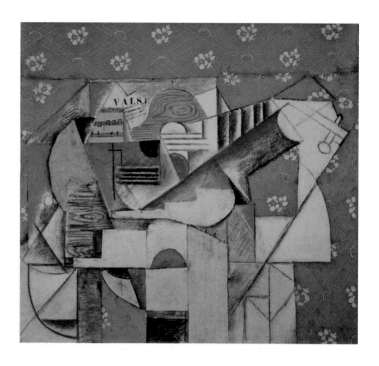

What motivated this radical departure in picture making? Perhaps social, economic and environmental changes in the Western world were partly responsible: the established order of society was breaking up; the power exerted by the landed gentry was waning as vast numbers of people looked towards industry and commerce for employment; and developments in science and technology enabled advancements in mass production, manufacturing and travel. The invention and subsequent mass production of the car and the aeroplane presented new ways of viewing and experiencing the world. Commodities and money flowed throughout society in increasing abundance, resulting in varying degrees of independence and freedom of choice for the consumer, both rich and poor. The burgeoning production and distribution of printed matter such as newspapers and magazines enabled people to access and share knowledge. Not only the printed media but also tickets, labels and wallpaper became, ironically, a valid art material, as collage began to enter the realm of fine art.

Some of the aforementioned technological advancements are reflected in the still-life subject matter of Picasso and Braque's collages of 1911/12. Pasted onto the picture surface were assorted papers such as newsprint, musical sheets, tickets, discarded scraps of decorative wallpaper. Some of these printed papers showed clearly recognisable simulated wood and chair-cane effects, with no attempt being made to disguise their true nature, making reference, albeit perhaps ironically, to manufacturing techniques. These collages could be described as celebrating a new kind of life, namely, the materiality of the modern world. This was a radical break from the notion that art should be a universally recognisable window on the world. But the new visual language would nevertheless inspire future generations of artists to extend the boundaries of what could be defined as art.

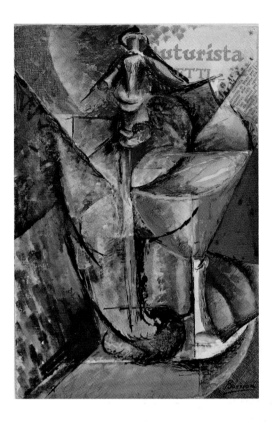

Boccioni, *Still Life with Glass and Siphon*, 1914. Courtesy: Yale University Art Gallery.

THE FUTURISTS

The Futurists were an Italian art movement founded in 1909 by poet Filippo Tommaso Marinetti. Their fundamental aim was to embrace and celebrate the modern world of science and technology, and to shed artistic traditions. In their manifesto of 1909 they declared that 'we will free Italy from her innumerable museums which cover her like countless cemeteries'.[3] Such was their passion to eradicate the past that they declared 'a new beauty', the beauty of speed. 'A racing motor car … is more beautiful than the *Victory of Samothrace*'. (The *Victory of Samothrace* is a famous ancient Greek sculpture in the Louvre Museum in Paris.)

In their collages the Futurists employed the pictorial devices of Cubism and the scientific approach to colour adopted by Divisionist painters such as Paul Signac to celebrate the vibrancy of the modern world. Objects and the space they occupy in Futurist still-life collages are generally recognisable, but in some the fragmentation is depicted in such a way as to express the underlying everyday appearance. This is particularly noticeable in Umberto Boccioni's collage *Still Life with Glass and Siphon*, dated 1914.

The siphon and glass placed on a surface are represented in the Cubist style. Objects and space are drawn from different viewpoints and fused together. The spatial quality is ambiguous – background and foreground areas jostle and overlap with each other, creating a bewildering sensation. Are the objects in deep or shallow space? However, two aspects show that there is a significant departure from Cubism. Firstly, with regard to the collage, the original working surface has many layers of pasted paper forming a varied, rich textural ground on which Boccioni has drawn his images, whereas the Cubists did not draw and paint on pasted layers of different papers in this way.

Secondly, the expressive, heavy, black, jagged quality of the curved lines that radiate out from the vertical core of the siphon bottle demand

attention, forcing the viewer to examine more closely the materiality of the object, whereas the lines in Cubist collages are more continuous and possess a quieter nature. The mysterious amorphic quality of fleeting light on objects, especially glass objects, is captured through the use of subtle tones of blues, pinks and greys painted in the Divisionist technique.

Reflected and refracted light decomposes and recomposes the solid masses of this arrangement. The dark expressive curved lines allow us, just about, to recognise the objects and space. A metamorphosis has taken place; the objects and their surrounding environment are not totally recognisable as solid static entities. In fragmenting the objects and surrounding space Boccioni has created a sense of fluid dynamic energy: solid mass and surrounding atmosphere interpenetrate and become almost indistinguishable.

The Futurists would have been aware of Einstein's mathematical proof in a paper written in 1905 of the existence of atoms. These, it was discovered, are not static in nature but made up internally of fast-moving electronic particles, known as electrons. Boccioni's collage reflects this realisation and expresses the dynamic pioneering spirit of this artistic movement.

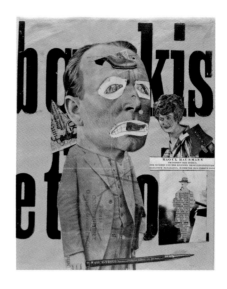

The Art Critic, Raoul Hausmann, 1920/21. © ADAGP, Paris and DACS, London 2010.

DADA AND SURREALISM

Dada and Surrealism are difficult to separate because some of the Dada practitioners became Surrealists. Dada is a nonsense word, an absurd reaction to the meaningless horror of the First World War. The movement initially emerged in Zurich in 1916, in staged theatrical events at the Cabaret Voltaire at which artists, writers, poets and performers would gather to put on performances and exhibit art whose primary motivation was to offend as many people as possible. The movement spread quickly across Europe to Berlin, Cologne and Paris, and even reached New York. Irrationality and satire were key features. The artist Marcel Duchamp asserted that anything could become a piece of art – a bottle rack, a bicycle wheel, even a urinal! These pieces of art, known as 'readymades', embodied the radical nature of their ideas.

Dada artists often used collage, which was then regarded as a radical medium, as much for its method as its aesthetic quality: the physical act of cutting, tearing and pasting engendered a mood of energy and speed; the rapid selecting, cutting and pasting of papers onto a surface bypassed the more labour-intensive process of drawing and the careful, meticulous mixing and application of colours. This relatively new technique was ideally suited to the artistic aims of the Dadaists, namely, shock, provocation and agitation.

Raoul Hausmann's collage *The Art Critic* (1919/20) is a clear statement of the artistic principles of Dada. The photographic imagery on the paper, not its aesthetic colour value or texture, is the most important aspect. The crudely cut-out paper representing the eyes and mouth of the central figure of the art critic, with its oversized, unsmiling head. He holds a raised pen that has been enlarged, leading the viewer to question the scale and positioning of the familiar art critic's tool. The pen could resemble a sword or bayonet; indeed, its potential use as a weapon is suggested by the way the man is holding it, his conventional three-piece suit notwithstanding.

In keeping with the main artistic principle of Dada, Hausmann's depiction of a familiar, perhaps despised member of the art establishment is satirical, even outrageous. In her book *Surrealism*,

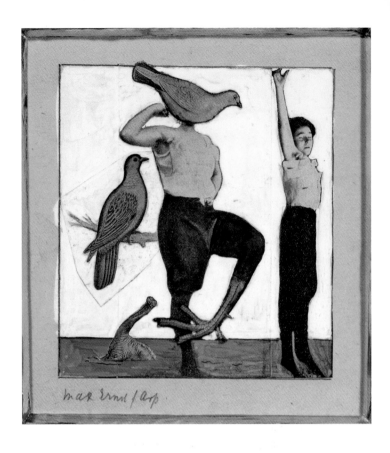

Physiomythological Diluvian Picture, Max Ernst and Hans Arp, 1920. © DACS 2010.

Fiona Bradley vividly conveys the emotional effect of this seminal Dada collage: 'The critic, reassembled from the dismembered fragments of his own methods of discerning and disseminating opinion of artistic 'value' (he is made from parts of newspapers and magazines, stabbed in the back on the neck by a banknote), speaks only gibberish.'[4]

The Surrealist artists that emerged in the 1920s were concerned with exploring the workings of the unconscious mind through dreams and hallucinations. Some of these artists had been Dadaists, and many of the ideas and pictorial techniques that were pivotal to Surrealism had already been established by the earlier movement. The Dada exploration of irrationality was manifest in the way Surrealist artists depicted illogical juxtapositions of recognisable objects. Shifting perspectives allowed objects and people to float in a space that, again, could be either deep or shallow. There is no single light source; everything is evenly lit. The familiar physical appearance of things has undergone a transformation, a metamorphosis, and everything has become uncertain, dreamlike – super-real. The Surrealist collage artists, especially Max Ernst, drew inspiration from a wide and varied range of printed matter. Photographs were cut out of books on geology, botany and mineralogy and combined with figures from fashion magazines and knitting patterns. Disparate shapes and textures were carefully juxtaposed and pasted onto a surface in order to create a fantastical imagery.

Max Ernst and Hans Arp's collaborative collage *Physiomythological Diluvian Picture* of 1920 is an early example of Surrealist art. The figures appear in uncertain space; the one on the right floats with a hand that is cut off at the top of the picture, while the other, represented as a hybrid, is possibly standing in water, as the right foot is blurred and the surrounding colour is blue. A metamorphosis has again taken place with the figure on the left, which is half man, half bird. The bird resting on a branch that seems to emerge from the back of the hybrid figure as well as the dinosaur creature arising from the blue water are both clearly recognisable, but the space in which they are located seems small and compact and puzzling. Max Ernst and Hans Arp are playful with scale and distortion. The size and visibility of the right foot of the hybrid figure suggests shallow water, but the appearance of the half-visible dinosaur implies greater depth. Half of the right foot of the hybrid figure disappears off the edge of the picture, which, together with the apparent weightless right-hand figure, undermines the sense of gravity. There is no recognisable light source; sky and water are represented in even blocks of colour: off-white and blue. Is it day or night? The absence of familiar features such as gravity or a light source, along with the metamorphosis of recognisable shapes and distortions of scale, create a sense of disorientation. So we see from comparing this picture with Hausmann's that whereas the Dada collage is about an external reality – a satire of an established familiar person in the case of the Hausmann – the Surrealist collage is preoccupied with internal reality, inviting the viewer to experience a dream world where anything and everything is possible.

These artistic movements developed at a time when the Austrian psychiatrist Sigmund Freud was exploring the inner workings of the human mind through the interpretation of dreams. The publication in 1899 of Freud's *The Interpretation of Dreams* would have offered evidential support to the artistic aims of Dada and Surrealism.[5] Both movements were radical at a time of profound dislocation, when all the old certainties were being questioned. Some of these artists had personally experienced tragedy and loss of life on the battlefields of Europe, and all had experienced the resulting socio-economic chaos that occurred across the Continent, especially in defeated Germany. In this context, it would perhaps have been more surprising if they had not been so revolutionary when it was no longer possible to know what was correct, what was real, and who could one really trust. The medium of collage was the ideal artistic vehicle to forcefully reflect this sense of fundamental fracture. The fragmented images created by cutting and pasting together layers of different, unrelated papers were ideally suited to expressing the social disorder they saw and felt around them.

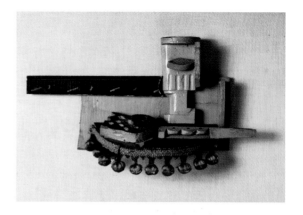

Still Life, Picasso, 1914.
© Succession Picasso/
DACS, London 2010.

THE FOUND OBJECT

Art created from the found object originally
appeared in the early collages of the Cubist
artists. Discarded items such as tickets, menus,
sheet music, newspapers, pieces of wood,
cardboard, wire, soft furnishings and the like
seemed to have a bewitching charm. A good
example is perhaps Pablo Picasso's *Still Life*
(1914), which comprises a curved piece of wood
with a decorative fringed tassel attached to it,
supporting a glass, a knife and a piece of bread
covered in salami slices, which are fashioned from
wood and other non-edible materials.

This is a playful juxtaposition of unusual
materials that have, with the exception of the
fringed tassel, changed identity; it pre-dates
and therefore anticipates the Surrealist impulse.
During the years 1914 to 1922, artists in various
countries, apparently unknown to each other,
began adopting similar styles and themes using
the technique of collage to incorporate the
found and discarded object in art works. This
apparent simultaneous use of the found and
discarded object by unconnected artists could
perhaps be described as coming from a shared
artistic consciousness, which had at its core the
liberating pictorial language of Cubism.

The Russian Constructivists, the Italian
Futurists, along with the Dadaists and Surrealists
emerging in Germany and other countries
(principally in Switzerland and France) at that
time, all experimented with collage and adopted
Cubist techniques when working with this
medium. One might ask whether they were forced
to embrace collage as art materials may have been
in short supply in the early 1920s, and materials
for collaging could come from any source and thus
were cheap and easy to obtain. Whether this was
a choice of necessity or not, the result was an art
that aptly expressed the socio-economic distress
of the age.

The discarded object had cast a magic spell.
Artists were fascinated with the possibilities and
opportunities it offered. The aesthetic beauty of
items that would otherwise have been thrown

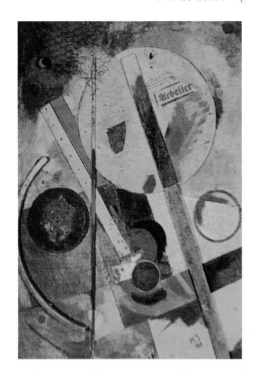

out with the rubbish was being celebrated for the first time in art history. It was a revolution in perception. The German artist Kurt Schwitters was a particular champion of the overlooked art material. Schwitters lived in Hannover in Germany and is known to have associated with many avant-garde artists across Europe in the early 20th Century, including the Dadaists in Berlin. His collages, however, do not reflect the anti-establishment and provocative views of the Dada movement.

For Schwitters, the motivation was to celebrate the inner beauty of non-artistic materials and the harmonious way in which they could interact with each other in a collage. In a spiritual context, this activity helped him make sense of the chaos that existed in the external world. As he explains, 'One can even shout out through refuse, and this is what I did, nailing and gluing it together. I called it "Merz"; it was a prayer about the victorious end of the war, victorious as once again peace had won in the end. Everything had broken down in any case and new things had to be made out of fragments, and this is Merz. It was like an image of the revolution within me, not as it was, but as it should have been.'

In the *Arbeiter-picture* fragments of printed and plain paper, cardboard, rope, wire mesh, wheels, buttons and broken pieces of driftwood are delicately balanced, forming a rhythmic whole. Geometric shapes and a limited range of colours and tones are assembled, revealing the techniques of Cubism. Circles hover against a backdrop of areas of flat and subtly gradated tones of colour. Once again, are they in deep or shallow space? The layering of tones and colours and overlapping lines and curves confuse and intrigue the viewer; there is no gravity as shapes appear to float in an indefinable space and travel beyond the picture frame. Unlike Cubism there are no deliberate representations of the external world in the form of figures or objects. A metamorphosis has again taken place, as the physical appearance of the discarded fragments has changed; they have been given a new identity and absorbed into a world of geometry.

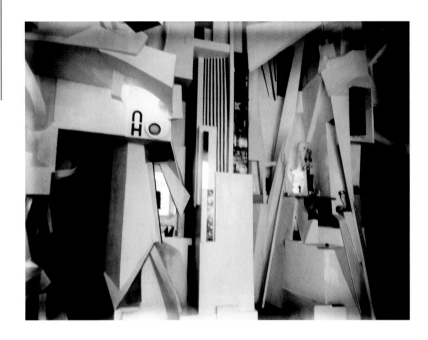

Picture of a section of *Hannover, Merzbau*, Kurt Schwitters, c. 1933. © DACS 2010.

Schwitters employed the techniques of Cubism and pushed the artistic boundaries further, creating a world of abstraction where colour and shapes exist and are celebrated in their own right and do not have to represent anything definable in the external world. Schwitters's and other artists' use of collage played an important part in establishing exciting possibilities for the 'found object' within the field of abstract art.

The two-dimensional collages of Kurt Schwitters were artistically radical, but so were his three-dimensional assemblages of fragments and discarded objects, the most famous being his *Merzbau*, which brought collage activity into new areas in the interwar years. Collage and assemblage within art are closely linked; both are about the collecting and bringing together of different things. The former is usually associated with the definite action of fixing materials to a flat surface, whereas the latter implies a more flexible, fluid arrangement where things can be dismantled, re-arranged and transformed into another work of art.

It is said that Kurt Schwitters's *Merzbau* assemblage, which evolved into the shape of a column as he added to it over a period of time, was linked not just to everyday life at a superficial level but represented deeper emotions. Over a few years, it grew upwards and outwards from his studio, gradually coming to inhabit various rooms and floors of his house in Hanover. The column was built with many openings into irregular spaces that varied in size and proportion, and contained personal mementoes of people who

were special to him. These mementoes included such items as a lock of hair, a half-smoked cigarette, a piece of necktie, a broken fingernail, a shoelace and a broken pen.

Werner Schmalenbach, who visited the *Merzbau*, described the experience as follows:

> The inside walls were perforated with entrances to caves, more or less dark, depending upon whether or not the electricity was functioning. Caves were dedicated to other artists, film stars, etc., i.e. a Gabo Cave and a Mondrian Cave, or aspects of his soul.

> The column evolved from a chaotic heap of various materials: wood, cardboard, iron scraps, broken furniture and picture frames, etc. Inside this column was the hidden life of Schwitters's soul, his struggle with all problems of life, art and language, and of human and inhuman relations.[6]

It is important to mention Kurt Schwitters's assemblages because they create a context within which one can try to understand some of the motivations of later 20th-Century artists such as Tracy Emin with her unmade bed, *My Bed*, which is surrounded by fragments of human detritus. Visual art aims to explore and express many complex areas of human existence and experience through both conscious and unconscious states of mind. As is evident from the *Merzbau*, art is not just about the superficial harmonious beauty of shapes and colours. The objects within the enclosed spaces in this assemblage express a range of human longing – sentimentality, desires, hopes, dreams, memories and so on.

Collage, Cubism, the found object, the readymade and a touch of Dada despair and provocation could all be regarded as roots from which post-modernist artistic thinking and subject matter was to develop.

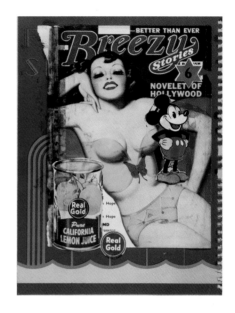

POP ART

Pop art emerged during the early 1950s, taking its source material and ideas from a variety of areas within popular and commercial culture. The movement reached its climax around the mid-1960s and then, predictably, as with all artistic movements, gradually lost its inner momentum and sparkle and slowly disappeared. Photographs, events and general information contained in newspapers and magazines were of primary interest to the Pop artists. Any and every topic was worthy of representation, including scientific discoveries, technological and manufacturing innovations, politics, sport, fashion, food, films, celebrities, TV, advertising, labels and packaging. There was an abundance of things to be purchased, experienced and enjoyed by both the rich and the poor. The mass consumer culture had arrived in earnest and every aspect of this seemed to be reflected in the work of Pop artists, especially their collages.

These pieces reveal a fascination with not only the content of the material used, but also the activity of collecting, selecting and bringing together unusual and unrelated images. When fused together these disparate images become something else – developing a novel and somehow weirdly incomprehensible compatibility. This is particularly the case in the early scrapbooks of the Italian Scottish-born artist and sculptor Eduardo Paolozzi, which were brought together in the Yale Iron Scrapbook created between 1948 and 1953.

As a child Paolozzi was an avid collector of printed matter and is known to have been creating scrapbooks of images relating to mass culture from the age of 10. The above page relates to his time in Paris and London, when, as an art student during the mid-1940s, he came across magazines brought over from the USA by American GIs visiting and studying in Europe at that time. Paolozzi was so enthralled with the imagery and the vibrant colours found in these American magazines he referred to them as 'a

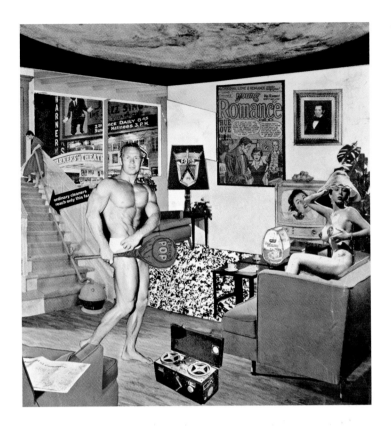

Just What Is It That Makes Today's Homes So Different, So Appealing?, Richard Hamilton, 1956. © Richard Hamilton. All rights reserved, DACS 2010.

catalogue of an exotic society, bountiful and generous, where the selling of tinned pears was transformed into multi-coloured dreams, where sensuality and virility combined to form ... an art more subtle and fulfilling than the orthodox choice of the Tate Gallery or the Royal Academy'.[7]

This quote suggests, at least in the eyes of Paolozzi, that a fragment of paper with a readymade photographic image advertising a consumer product such as tinned pears – considered by many as 'low' art – should be regarded in the same terms as, if not higher than, the 'high' art of traditional painting as exhibited by the major art institutions. The introduction of 'low' status materials – the discarded, apparently valueless object or fragment – into the world of fine art had its origins in the quiet and decidedly aesthetic collages of the Cubists. However, Pop

art realizes another potential for printed paper fragments, often using them to celebrate a mood of joy and optimism that prevailed in the West in the 1950s, as well as with a sense of quiet irony. This can be seen in the subject matter of the collage entitled *Just What Is It That Makes Today's Homes So Different, So Appealing?* by the British Pop artist Richard Hamilton.

The main area of the picture features an interior space filled with sleek modern geometric furniture. The man and woman exude good health in an environment that reveals newfound material comforts and pleasures derived from recent advancements in technology: the vacuum cleaner, the TV, the tape recorder. An enlarged tin of ham makes a powerful socio-economic statement: post-Second World War food rationing in Britain is over – one can show off, as there's an abundance

of food in the larder. The shiny floor, textured carpet and plain walls reveal the radical change in interior design. The lack of adornment on these surfaces shows a reverence for new products and their function. There are also other aspects that reflect the celebratory nature and challenging motivations of Pop art. For example, the large, framed mass-produced poster that is allotted more wall space than the Victorian fine-art portrait – actual evidence in a domestic interior of 'low' art (the mass-produced poster) having greater prominence than the 'high' art painting with its ornate frame. The ceiling area is ambiguous. Could the curved beige shape floating above the black area be a reference to a planet or the moon and mankind's burgeoning interest in the possibility of extraterrestrial life, or is it just a painted circular shape on a black ceiling? Looking across through the windows to the outside, pleasure beckons with a possible visit to the theatre.

Some of the techniques of Cubism appear in this collage: space is slightly tipped up, while the flat area of textured carpet has no change in tone (the technique normally employed by painters to imply spatial recession) as it sweeps toward the plain yellow wall. There is a playfulness here reminiscent of Cubism and Surrealism: are we looking through a glass ceiling to the sky, or is it a painted ceiling in beige and black? Are we

looking up into shallow or deep space? Identifiable everyday objects have changed scale – the tin of ham in the middle area of the picture is the same size as the tape recorder placed in the foreground – giving the whole picture a dreamlike quality.

In January 1957 Hamilton, in a letter to Alison and Peter Smithson, wrote that the Pop art meant, 'Popular (designed for a mass audience), transient (short-term solution), expendable (easily forgotten), low-cost, mass-produced, young (aimed at youth), witty, sexy, gimmicky, glamorous and, last but not least, big business'.[8]

These words relate to the collage illustrated on the previous page and reflect many of the motivating forces governing the Pop art movement. However, when one looks at the collages that the American artist Robert Rauschenberg produced around the same time, which contain the same raw material associated with this movement – namely, fragments of printed paper – one senses anguish, expressed by the gestural style of over-painting the layers of paper with heavy daubs and drips of paint. The paper in this collage has not been selected for its aesthetic qualities; but appears rather to have been randomly chosen. Layers of paper are fixed haphazardly to the canvas and smeared with paint. The colour and textural values of paper and paint intertwine and the whole painting is abstract.

Collection (formerly Untitled),
Robert Rauschenberg, 1954.
Oil, paper, fabric, wood and
metal on canvas; Gift of
Harry W. and Mary Margaret
Anderson. © Estate of Robert
Rauschenberg. DACS, London/
VAGA, New York, 2010.

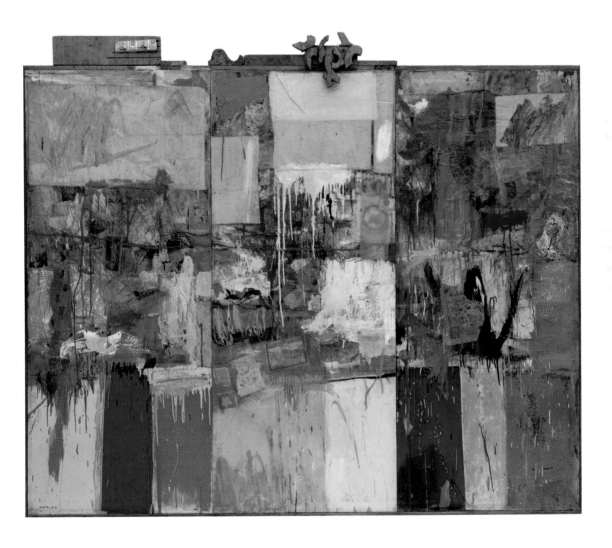

COLLAGISTS– POST-POP ART

Many artists have continued to use collage as a medium throughout the second half of the 20th century in varied and exciting ways. For example, in the 1960s British Pop artist Peter Blake used collage for his famous cover of The Beatles LP *Sergeant Pepper's Lonely Hearts Club Band*. Referring to this record cover in an interview with author Natalie Rudd entitled 'About Collage', he said, 'If you bought the record you also bought a piece of art on exactly the level that I was aiming for'.[9]

Peter Blake, true to his original intentions as a Pop artist in the 1950s, was providing art that was inclusive and accessible. He has continued to work in this medium, combining his lifelong interests in 'typography, pop music and popular culture'.[10]

The technique of décollage began emerging within the ranks of European avant-garde artists during the 1950s and '60s. Jean Tinguely, Daniel Spoerri, Raymond Hains and Wolf Vostell in Paris and Mimmo Rotella in Italy were among the artists working in this medium. They ripped posters from street advertising hoardings and randomly pasted the paper remnants onto canvases in their studio, fusing them into layers, creating collages that comprised many meanings. Unusual juxtapositions were created through

chance and the history of the layers of posters was of especial interest to them. These artists were part of the movement which became known as *Nouveau réalisme* (new realism), seen as 'the European counterpart to Pop Art'.[11] Some of the collages in Part 2 show that their techniques have been taken up and adapted by later artists.

The creative power unleashed by the early collage artists has been a primal force. They created new and unimaginable freedoms for artists working in this medium: an unlimited idea of what art could be about as well as limitless choices and combinations of materials that could be used in a work of art. Who could have predicted in 1911 that elephant dung from Whipsnade Zoo, along with glitter and pins, would be the materials used to create a portrait, Chris Ofili's *No Woman, No Cry*, to be exhibited as a piece of fine art in a major national gallery?[12]

So collage and the art of attachment, as you can see, has exerted an exciting influence on fine art over the 100 years since its origins in Cubism. I hope that this short history has provided a useful point of reference from which to begin to understand and appraise the work of contemporary artists – some famous, some less well-known – who continue to use this medium.

Poster for Live Aid, Peter Blake, 1985.

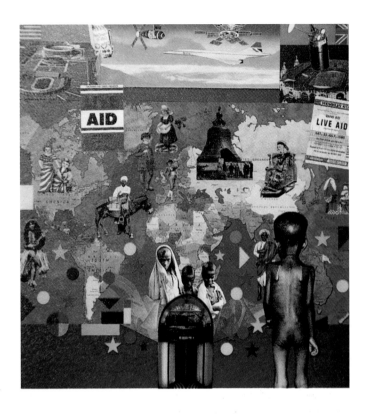

Chris Ofili, *No Woman, No Cry*, 1998. Acrylic, oil, polyester resin, pencil, paper collage, glitter, map pins and elephant dung on linen.

2

PART TWO:
A SELECTION OF
CONTEMPORARY
COLLAGE ARTISTS

This part of the book showcases work dating from the late 1950s to 2010, created by 16 collage artists from a range of cultural backgrounds as diverse as Iran, Iraq, Lebanon, Palestine, the United Arab Emirates, the United Kingdom and the USA. Some have experience spanning half a century, others much less. One or two might be described as emerging artists, but that does not diminish the importance of their contribution to the groundbreaking developments in early 21st Century collage.

The subject matter and inspiration of these artists displays a broad range of interests: Zen Buddhism and Japanese culture; wars, past and present, entwined with social and political events; mythological stories and aspects of ancient civilisations and customs adapted to explore contemporary issues; in fashion, the combination of modern and traditional materials which explore and experiment with colours, tones and textures, suggesting the possibility of a new aesthetic in the area of personal attire; and domestic scenes and the still-life genre, reminiscent in technique and subject matter of the Cubists of the early 20th Century.

These diverse responses to nature, the landscape, architecture and the world in general are all explored using the medium of collage: from the micro – the beautiful pattern of cell structures of leaves, flowers and grasses – to the macro – broad expanses of coastline and ocean, textures and colours of rocks, boats and buildings. This is the versatility of collage.

Each artist says something about their motivation, technique and materials. Some reflect on the artists from the past and present that may have influenced them. Nearly all have acknowledged directly or indirectly the legacy of Cubist and Dada artists and the freedoms that these artists from the early years of the 20th Century opened up, not only in their revolutionary representation of space and objects on a flat surface, but in their introduction of collage and assemblage and the boundless idea of the kinds of materials, artefacts and ideas that could be presented as art.

The selection begins with Sandra Blow RA (1925–2006), regarded by many as the 'Queen of Collage', and the other artists are then presented in the following, alphabetical order:

Fereydoun Ave	**Ann Manie**
Polly Becker	**Roy Ray**
Zara Devereux	**Angela Rudge-Litten**
Anthony Frost	**Steve Sabella**
Jason Hicklin	**Fatma Saifan**
Nadine Kanso	**Rashid Salim**
Denny Long	**Tamsyn Williams**
Hanaa Malallah	

There are of course many other artists working in the medium of collage, but this is a personal selection of collage artists all of whom, with the exception of Sandra Blow, I have met and been able to talk to directly about their work. I hope that, in enjoying their contributions, you will also feel emboldened to seek out other artists using collage.

SANDRA BLOW
RA (1925–2006)

Sandra Blow was born in London and studied at the St Martin's School of Art (as it was then called) and the Royal Academy Schools in London, and also at the Accademia di Belle Arti in Rome. She is regarded as a major artist from the British abstract art movement that evolved in the mid-1950s.

In the spirit of 20th-Century Italian *Arte povera* artist Alberto Burri, the materials that Sandra Blow used were often discarded items such as sacking, sand, cement, plaster, ripped canvas and sawdust. Her early works are mostly part-collage and part-paint, and the colours – reds, browns, greens and ochres – are dark in tone, reflecting the textures and weather-beaten surfaces of the landscape of Cornwall in England, where she lived during the 1950s. It has often been noted that, although her work is abstract (i.e. none of her images is representational of the real world),

echoes of the sensations of Cornish landscape are perceptible in the early collages – its rich textures and rugged sweeping shapes of rocks, coastal paths, barns and wrought-iron farming equipment. Her later work, made upon returning to Cornwall from London in the early 1990s, is light and airy, with thin washes of acrylic paint. Tones are lighter and shapes are subtly balanced with touches of pure primary colour.

Within Sandra Blow's collages there is usually an inexact geometry with an organic feel, and a rugged, uneven quality can be perceived in the lines and curves of the cut-out shapes. No attempt is made to hide the nature of the materials and method of construction; they are what they are – discarded offcuts of papers lying around her studio. In *Relievo*, as in many of her works, some of the papers are only loosely stuck down and edges protrude from the surface.

Cornwall, Sandra Blow, 1958.
Oil, plaster and sacking on board,
119.4 x 110.5cm (47 x43½in).
Courtesy of Sandra Blow Estate,
© DACS 2010.

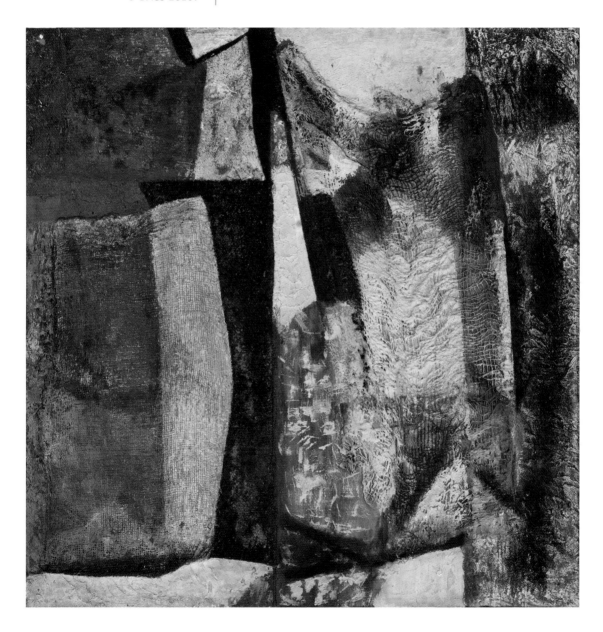

Relievo, Sandra Blow, 2005.
Paper collage, 71 x 66cm
(28 x 26in). Courtesy of Sandra
Blow Estate, © DACS 2010.

However, when viewed from a short distance a beautiful rhythmic harmony of shapes and colours is discernible; soft, flesh-coloured, semitransparent paper rests on top of a denser, robust, cream cartridge paper. Different qualities of paper, translucent and opaque, mingle, and the unstuck, peeling paper casts soft pink and blue shadows. Delicate tones are set alongside slivers of bright colours – red, orange and blue. Corrugated paper strips surround the picture but do not totally enclose it; where these strips are fragmented, thin strips of pink make an appearance, near the top and bottom corners of the corrugated frame. The whole collage is a delicate balancing act.

In his essay 'An Artist of Nature', Mel Gooding describes Blow's working technique and ultimate aim in the following words: 'She favours collage because it enables her to make constant apperceptive adjustments: add a colour-shape here, subtract a colour-shape there, move this shape to that side, that shape to this side. And then? The moment of coherence! – "a balance of space, colour and shape, held in a pictorial structure"; the visual poetry of "a great clear simplicity"!'[13]

Sandra Blow has summed up her inherent artistic aim in the following words: 'There should be a startling rightness in a work, an unexpected quality about it, an element of surprise.'[14]

This collage seems to me to capture all of those aims and confirms why she is known as the 'Queen of Collage' of the late 20th and early 21st centuries.

FEREYDOUN AVE

Fereydoun Ave was born in Tehran in 1945 and brought up and educated in England. He spent the early part of his career working in film and theatre and completed a BA in Theatre Arts from Arizona State University in 1969. He studied film at New York University in 1969/70. During the 1970s, as well as working in stage and graphic design Fereydoun was also closely involved with the Iranian national art and entertainment world. He was resident designer for the National Theatre in Tehran and adviser to National Iranian Television and the Shiraz Arts Festival. In Fereydoun's current work the artistic inspiration is threefold: history, narrative and the cultural traditions of his home country.

This photomontage of wrestlers is entitled *Rostam in Late Summer Revisited* and is one of a series of seven images, reproduced in 2010 as a limited edition of inkjet prints on canvas. In a press release for an exhibition of similar works by Fereydoun featuring *Rostam*, it was explained that, 'Each of these works depicts the pre-Islamic wrestling hero Rostam, a character drawn from the Persian poet Ferdowsi's epic *Shahnameh* (Book of Kings). Using images of a well-known contemporary Iranian wrestler or Pahlavan (strong man) to portray Rostam, the artist pays homage to Persian tradition and a particular fondness for the past; the wrestler gloriously embodying these cherished values', and that, '... Rostam is depicted amongst lavish blooms, his figure duplicated with multiple arms, reminiscent of supernatural Hindu gods and goddesses, in evidence of Ave's innate spirituality'.[15]

The distant past and the present are harmoniously interwoven using collage and contemporary printing techniques. Fereydoun explains why he enjoys using collage and the subsequent pleasure and flexibility that occurs when it is combined with modern technology in the following way:

> It's so liberating to play collage. It's so great to see ready and available exactly what you imagined, and cut it out and paste it in, or, sometimes just to have as a springboard, a ready-made image to freely dive off of into a sea of other stuff, multiplied many times.

> It's great to recycle works that did not work in their entirety, but torn up and mixed up and added to they become new and work.

> The main problem with collage is the pasting, the glue, because it eventually stains and dries out. But technology has solved that with Photoshop, where one has unlimited images at one's disposal to choose from and cut and paste and print without actual glue. The rest is pure joy.

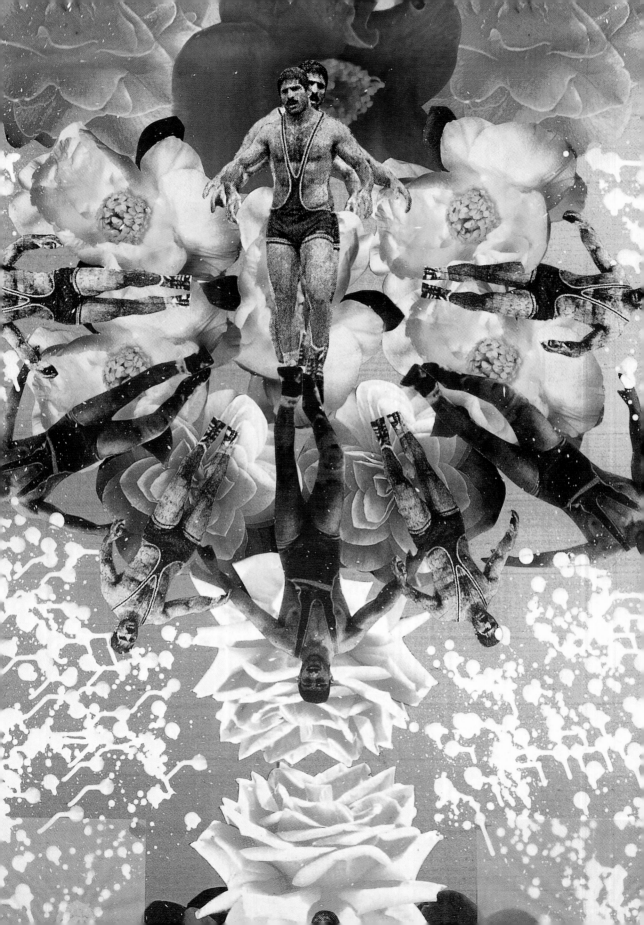

Rostam in Late Summer Revisited, Fereydoun Ave, 2010. Inkjet print on canvas, 100 x 65cm (39½ x 25½in). © Fereydoun Ave, Courtesy of Janet Rady Fine Art.

POLLY BECKER

Polly Becker began working as an illustrator using India ink and scratchboard, in the manner of old woodcuts. She says that after a decade or so of trying to draw things 'right' and depicting tonal shifts with groups of lines which tapered gradually in thickness, she suffered a crisis of frustration with the limitations and tedium of this style. This led her experimentally to begin to assemble diverse sculptural parts and found objects such as glass bubbles, wood, sequins, silk, semiprecious stones, crystals, cut-out photographs and porcelain. The collages are fixed onto antique mirror panels with water-clear silicone. This has been a liberating shift;

the resulting style makes for more flexibility, emotionality and spontaneity.

In the intervening years Polly has been honoured with many professional awards. Her work has appeared in juried annuals and on book jackets, and has been widely commissioned by magazines and newspapers. She has lectured at various institutions and done some teaching of illustration at university level. Polly's sculptures have been exhibited in galleries in New York, Boston and San Francisco, and at art fairs in London and Dubai. At the time of writing (2010) she was working on a stop-motion animation and a children's book. Polly lives in Boston, Massachusetts.

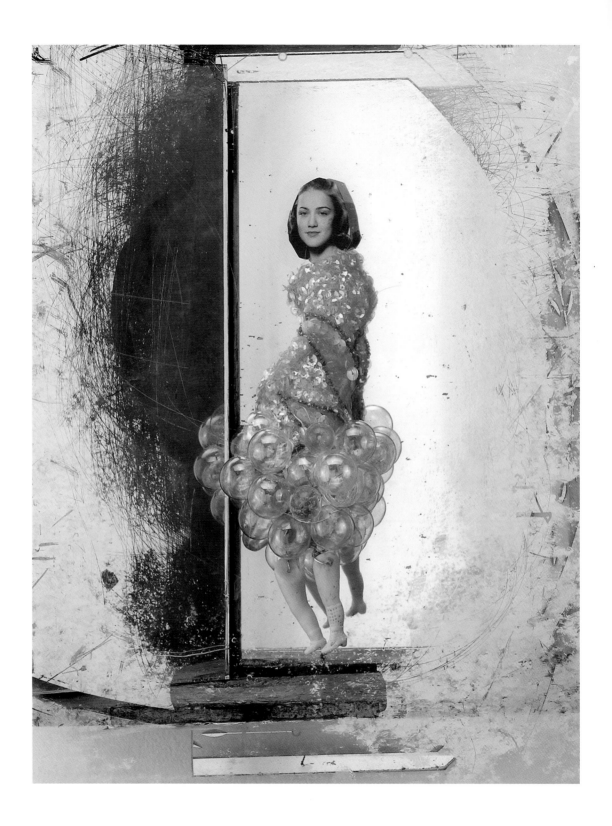

MIXED MESSAGES | THE VERSATILITY OF COLLAGE

Chelsea, Polly Becker, 2010. Antique glass, antique etched mirror, glass bubbles, hand-stitched sequins, porcelain, wood, 43 x 33cm (17 x 13in).

Joan, Polly Becker, 2010. Antique glass, clear resin, silk, porcelain, semiprecious stones, silk twine, wood, Swarovski crystals, 91 x 38cm (36 x 15in).

ZARA DEVEREUX

Zara Devereux was born in Cornwall and has lived there for most of her life. On completing a foundation course in art and design at Falmouth School of Art in Cornwall in 1986, Zara was not convinced that she wanted to be an artist. During the early 1990s she went to live in London, where while working for a fine-art framer she began to collect offcuts and scraps of handmade papers that were used for bespoke mounts. Zara explains that 'it seemed an obvious step to use them in collage'. With regard to the embroidery in her collages, she says, 'The embroidery was an accidental find – producing collages for Liberty's on a late-night deadline I realised I was out of glue and stitched the collage together – I have used stitching to enhance and strengthen works ever since.'

Entwined was produced following an autumnal printmaking and papermaking project at Trebah Gardens in Cornwall. The project offered the opportunity to view leaves through an electron microscope, revealing that even the plainest vegetation contained a fabulous pattern of cell structures. This piece seems to reflect both the external and internal forms of the leaves and grasses used. The plant images are all monoprinted from pressed botanicals, passing through the press up to four times with subtly different coloured inks. These tiny prints are then collaged onto handmade paper and embellished with stitching and watercolour.

Zara's key artistic influences are a diverse crowd. 'My mother, Jenny Devereux, is an etcher whose work has most definitely influenced me in technique, and we often head out on collecting days looking for leaves, flowers and grasses which we use in our work in quite different ways. Lenore Tawney, Antoni Tàpies, Elizabeth Blackadder and Victoria Crowe are all artists who I admire.'

Entwined, Zara Devereux, 2005.
Handmade paper, watercolour,
monoprint and stitching,
15 x 22cm (6 x 8¾in).

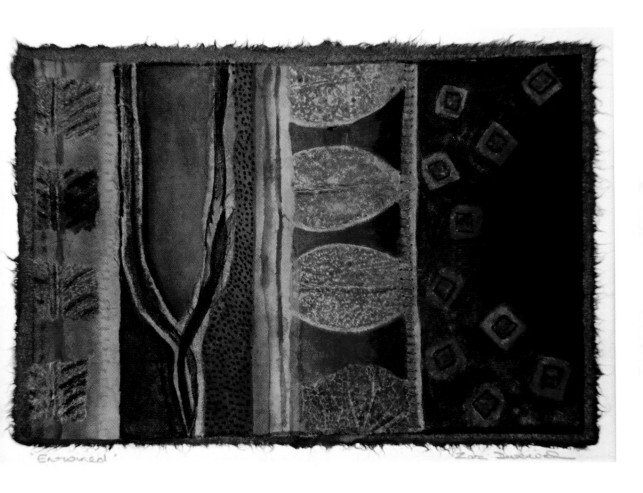

Beautifully Uncertain,
Anthony Frost, 2008. Mixed
media, acrylic and pumice on
netting, sacking, hessian scrim,
onion sack, mesh ripstop and
canvas, 99 x 99 cm (39 x 39in).

ANTHONY FROST

Anthony Frost was born in St Ives in Cornwall in 1951 and is the son of the abstract artist Terry Frost, who also worked in collage. He studied at Cardiff School of Art from 1970 to 1973 and now lives and works in Cornwall.

The core of Anthony's abstract works lies in his love of shapes, pure colours and textures. Materials and inspiration work hand in hand and are inseparable in the creative journey. He never works on an empty, flat canvas. The starting point is the collage. Materials such as brightly coloured hessian and netting are randomly placed across the picture's surface, and this influences the subsequent selection of other colours. At the outset there is no definite intention – anything is possible. Paint is applied and in some instances it acts as glue in the collage; lines are generally incorporated towards the end of the work. In his studio, an array of pots of different coloured acrylic waterproof paints is situated next to arrangements of materials that have been accumulated over time from a variety of sources. Scrap materials such as ripstop (marine fabric from which sails are made), brightly coloured netting (used for containing and transporting fruit and vegetables), hessian, scrim, discarded torn post-office bags, old cushion covers, surplus sofa material, pieces of found wood and metal all wait to be transformed into a work of art.

Although Anthony's work is abstract in the sense that he does not make deliberate and recognisable representations of the visual and tactile world, sensations of the things that surround him can be perceived in his pictures: brightly painted upturned boats gleaming under a sunny blue Cornish sky; bleached-out windows; peeling paint with layers of different undercoat colours breaking through, one colour activating another. The elements of Cornwall are captured in his paintings: his use of bright colours suggests the light and warmth of the sun, and the rugged, rich textural areas are evocative of the effects of wind, rain, sea and sun hitting surfaces over prolonged periods. Beautifully balanced, coloured, collaged shapes are imbued with a presence that holds the viewer's attention.

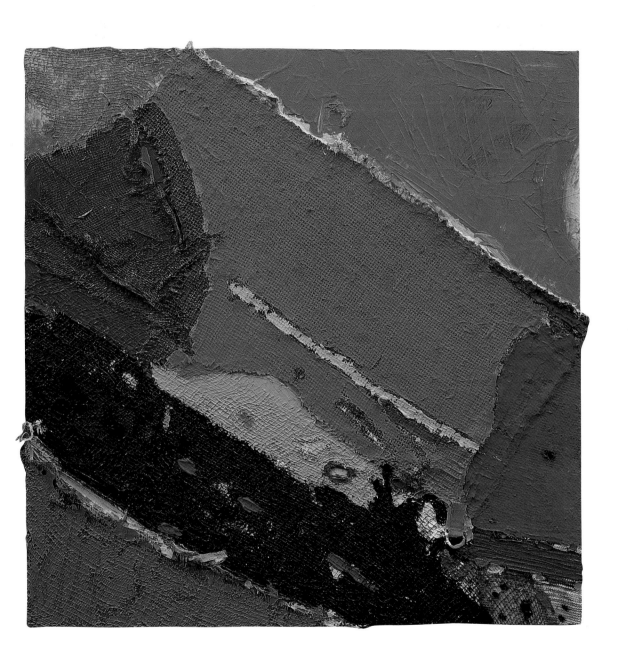

Detail from *Beautifully Uncertain*,
Anthony Frost, 2008

The author with Anthony Frost
in his studio in Penzance in
Cornwall.

When one looks closely at a piece of his work – through the bright colours, netting and other artefacts – the initial sketch can be seen as well as early pieces of the construction that convey the complexity of thought in the creative journey. Anthony explains these complexities: 'Some paintings paint themselves, but this is very rare. More often, there is a lot of backwards and forwards and leaving for a while. The painting dictates to you and it is a physical act.' He adds, 'Painting needs coaxing out by throwing ridiculous materials together and bringing things out that ring true and making sense of them.'

Anthony's abstract collages have a fluidity akin to music – colour, shape, texture and line have a rhythmical harmony of their own – so it was not a surprise to learn of his love of music and that he had designed the record cover for the rock group The Fall's *Extricate* album.

JASON
HICKLIN RE

Jason Hicklin studied fine art and printmaking at St Martin's School of Art in London and then completed a postgraduate course in advanced printmaking at the Central School of Art from 1990 to 1992. After completing his studies he went to work for the master printmaker Norman Ackroyd, who was a great inspiration. As Jason says of that period, 'I learnt to etch and teach, and he illuminated the world of business practice.'

Jason never uses a camera, insisting that 'It's about looking, seeing and attempting to understand what is in front of me.' There is evidence of decision-making in the proofs; it's a working practice on which he elaborates further: 'Occasionally, you see where you've made a wrong decision – working and not realising the unique. I get to the realisation of what I want through the step-by-step stage of producing proofs.'

All ideas are rooted in his sketchbook of Fabriano watercolour paper, which he takes with him wherever he goes. When working on location with his sketchbook, his favoured medium is graphite pencil and watercolour (the washes of tone are achieved with one fairly big Japanese watercolour brush, and brushes of size 2 and 3 are also part of his equipment); there is sometimes the odd etching plate.

Jason specialises in etching and incorporates a number of chine collés into his prints; the latter involves collaging paper onto a handmade print (see Part Three for further details of this technique). These prints are the result of much preparation, both physical and mental. There is the 'on site' work, often solitary and harsh, to experience first-hand the elements of land and seascape of the British Isles and Ireland. This involves walking, observing and camping, to make drawings and paintings which capture the fleeting visual drama that is created by changes in light and weather conditions. Then follows the reflective stage in the studio where Jason transposes and develops these experiences into chine-collé prints, as well as paintings and larger drawings.

Jason explains that chine collé can often amplify the sensations felt in the landscape: the delight of snow on rocks, the drama of the ocean's spray as it hits the shore and the subtle delicate tones and textures that make nature a deep and mysterious force.

Pendeen Tin Mines, Cornwall, Jason Hicklin, 1998. Etching and chine collé, 37 x 38cm (14½ x 15in).

Buckton Cliffs – Yorkshire, Jason Hicklin, 2006. Etching and chine collé, 25 x 49cm (9¾ x 19¼in).

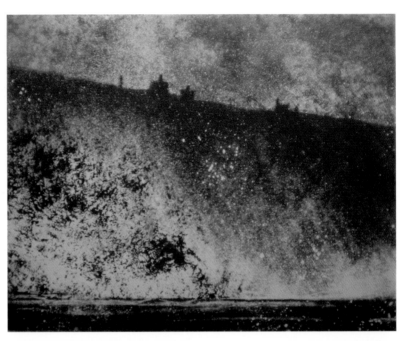

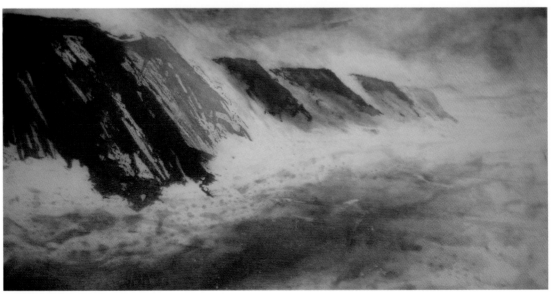

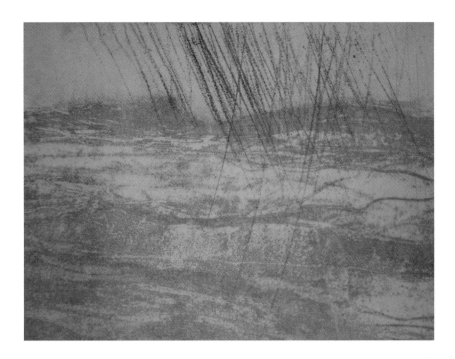

Jason was born and brought up in the city of Wolverhampton in England. A city historically associated with engineering – mainly light engineering – it is where as a child he says he established a relationship with and love of metal: 'I was always struck as a child by the smell of oil from the small working engines my grandfather, who was a boiler-maker, used to make in his spare time.'

Although he loved his city environment, Jason says that 'the excitement of a visit to the countryside or coast was an unbelievable privilege', and even now, when he travels from the Midlands to the sea or the countryside, 'the sense of the exoticism never diminishes'. The creative origins of an artist's work are always fascinating and Jason's love and engagement with land, sea and metal are no exception.

Jason has work in public and private collections; he regularly exhibits in both solo and mixed shows throughout Great Britain and is an Elected Member of the Royal Society of Painter– Printmakers. He has received many awards and fellowships in both Ireland and England and teaches at various institutions in the British Isles.

Dar el 7ay – Dubai, Nadine Kanso,
2010. Mixed media on photo
paper, 180 x 122cm (71 x 48in).
Courtesy of Gallery Isabelle
van den Eynde.

NADINE KANSO

The Lebanese artist Nadine Kanso has lived in
Dubai for many years, and this collage, entitled
Dar el 7ay – Dubai or *House of the Living*, represents
her day-to-day experiences over a ten-year period
from 2000 to 2010. Working on photographic
paper, Nadine has created a dotted outline of
the Burj Khalifa tower (Dubai's most famous
landmark – currently the tallest building in the
world) and glued the photographs inside it. The
image of the tower has been enlarged to match
her height of 173cm (5ft 8in). As she explains,
'The pictures were taken throughout the 10 years
I have been in Dubai. They are of people who live
in Dubai: friends, people in the street, people in
restaurants, and my aim is to reflect what I see
and what I am involved with and the social fabric
of Dubai. The Arabic lettering running down the
right-hand side of the picture is "2000 and 2010".'

Nadine has only recently begun exhibiting
collages, though in 2006 she took part in a
mixed show entitled *Arabian Artists* at the Victoria
and Albert Museum in London, organised by
Lebanese curators.

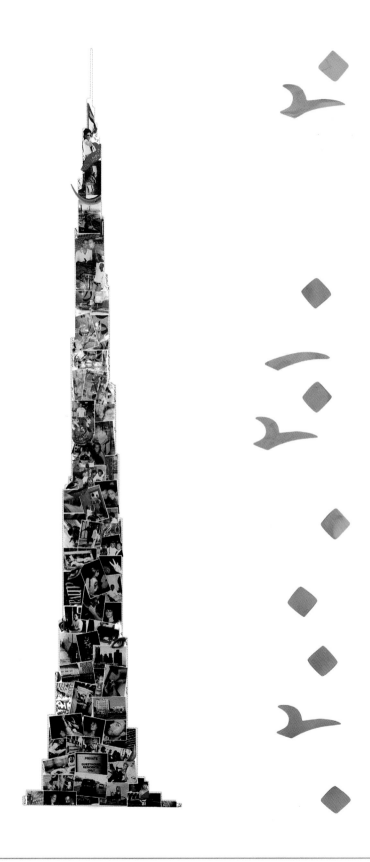

DENNY LONG (NÉE JOHNSTON) RWA

Denny Long was born in Bristol and currently lives in Zennor in Cornwall. As a student at the Bristol College of Art and Design in the 1960s, she specialised in ceramics. Visiting tutors to the college at that time included Bernard and Janet Leach, who encouraged her interest in Japanese culture and ceramics. Denny made many visits to the Leach Pottery in St Ives in Cornwall, which resulted in a trip to Japan and an introduction by the Leaches to Shoji Hamada at Mashiko in Japan. She has made several subsequent visits to the country and developed an interest in Zen Buddhism that is reflected in her current work.

Using traditional materials, handmade paper from Asia (Japan or India) and rice paste, she creates prints inspired by symbols from Zen Buddhism. The prints are produced using a combination of the following techniques: etching, aquatint, mezzotint and chine collè. A statement about her work on the Penwith Printmakers' website says, 'She uses universal symbols both timeless and ancient: the circle signifying the cosmos, the sun, the moon; the spiral, an idea of death and rebirth, rice grains, all living things or good fortune; the square emblematic of the four corners of the earth; and the triangle, a favoured motif, representing a mountain or the posture of meditation. Both her printing papers and inks reflect the colours of nature, terracotta, ochres, browns, blacks and greys. The overall effect of her work is one of calm, order and simplicity.'[16]

Criss Cross vii[1], Denny Long, 2004/05. Etching, aquatint, mezzotint and chine collé, 76.5 x 61cm (30 x 24in).

Inside the Mountain I, Denny Long, 2004/05. Etching, aquatint, mezzotint and chine collé, 76.5 x 61cm (30 x 24in).

Silver Moon III, Denny Long, 2004/05. Etching, aquatint, mezzotint and chine collé, 76.5 x 61cm (30 x 24in).

Sun and Mountain III, Denny Long, 2004/05. Etching, aquatint, mezzotint and chine collé, 76.5 x 61cm (30 x 24in).

 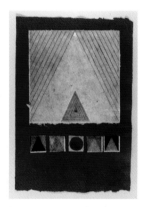

HANAA MALALLAH

Hanaa Malallah was born in 1958 in Thee Qar in Iraq, and has lived in the country for most of her life. She studied graphic art at the Institute of Fine Arts in Baghdad and obtained an MA in painting and a Ph.D. in art theory from the city's Academy of Fine Art. From 1998 to 2006 she lectured at the Institute in Baghdad, holding the position of Head of Graphic Art, but in 2007 she was obliged to leave for the UK under the Scholars at Risk Programme.

During the 1980s Hanaa met and came under the influence of Shaker Hassan Al Said, one of Iraq's great artists and teachers. Under his guidance many locally trained artists like Hanaa were drawn to Mesopotamian history through exposure to a vast array of historical artefacts that were displayed in the Baghdad National Archaeological Museum. This experience was to play an important role in the artistic direction that Hanaa would take. She has the following reflection on this period: 'Viewed as "modern", these objects – many of them marked or "ruined" by the passage of time – informed the aesthetic direction characteristic of the Eighties Generation. We deemed traditional art materials as incapable of delivering our artistic message. Instead we worked with burnt paper and cloths,

with barbed wire and bullets, with splintered wood and found objects, borrowing from history and our catastrophic present alike.'

The latter remark refers to the end of eight years of war with Iran, followed by Iraq's occupation of Kuwait, which led to the tragic 1991 Gulf War and the subsequent dreadful consequences – years of sanctions. She remarks that, 'For many of us, this "ruins technique" became the visual signifier of our cultural resistance and a carrier of our identity as Iraqi artists.'

The Shroud from 2009 clearly demonstrates the 'ruins technique' and the act of 'borrowing from history and our catastrophic present alike'. The use of fabric that is old and well worn, the cutting into squares and the burning, tearing and scratching of it amplify the sensation of ruin and destruction. Further examination reveals unusual symbols embedded within the cloth squares – collections of letters and numbers reflecting the ancient history of Mesopotamia, the earliest-known civilisation. Hanaa explains her artistic intention with the following words: 'The aesthetic aim has to reflect the original source in the very material and presence of the art work,' affirming that subject matter and technique are inseparable.

The Shroud is a multilayered collage. Initially, there is the surface quality – a geometric pattern of subtle tones and textures that catches the eye; then the surprise of a beautiful harmony achieved through the skilful placing and attaching of scraps of material with scorch marks, indicating the seriousness of armed conflict; then the symbols that connect us to ancient history. And still deeper meanings and motivations are revealed when one speaks to Hanaa. She describes her work as a spiritual journey in which collage helps her,

The Shroud, Hanaa Malallah, 2009. Mixed media of soft sculpture on canvas, 100 x 100cm (39½ x 39½in).

Picture of Hanaa's hand

'explore the hidden mystery that lies between two and three dimensions; between painting and sculpture; between the seen and unseen (hidden objects and partially revealed objects, fragments); boundaries between things; between line and form; geometry and nature'.

Similarities can be found with the collage artists working at the end of the First World War. Hanaa is reflecting and defining the world that she finds herself in, through technique and choice of subject matter. The situation parallels Kurt Schwitters and the Dadaists in 1919, as the inevitable economic consequences of conflict result in shortages in basic commodities. She describes life in Iraq after the Gulf War: 'As sanctions continued throughout the 1990s and art supplies became sparse, necessity rather than rebellion forced us to increasingly utilize found objects, recalling perhaps the Dada movement in Zurich at the time of the First World War.'

Hanaa Malallah is regarded as one of Iraq's leading female contemporary artists. She exhibits internationally and has work in many public and private collections around the world.

Louvres, Ann Manie, 1988. Paper collage and acrylic paint on board, 84 x 34cm (33 x 13½in).

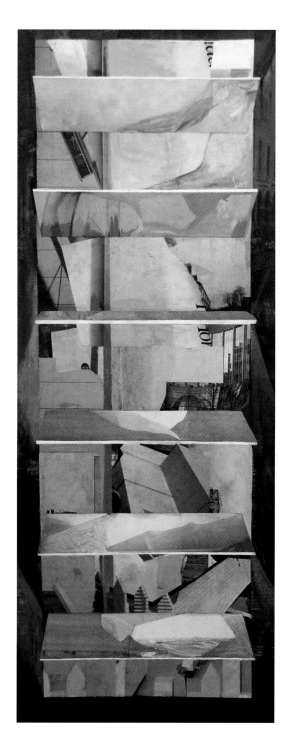

ANN MANIE

I started to explore the possibilities of using collage when studying fine art at the City and Guilds of London Art School in the 1980s. Pure painting and drawing from life of subjects such as the human figure, still life or landscape resulted in competent but dull work, and I needed a medium that would remove me a little from the subject, and help me to reinterpret reality in an interesting and exciting way. One of my artist heroes, the 19th-Century French still-life and landscape painter Paul Cézanne, made a famous comment about his own work that was highly significant to me at that time: 'I create pictures running parallel to nature'. I did not want to abandon representation of the tactile and visual world in favour of pure abstraction but, in the spirit of Cézanne, I wanted to explore, discover and express the underlying geometry and mystery that exists in different subject matter: in a still life, the interrelationships of space and objects; in a landscape, how old and new architecture aligns itself with nature and the elements; in depictions of interior and exterior spaces, the strange and bewitching juxtapositions that occur through reflected and refracted light on glass.

Lychees and Broken Plate, Ann Manie, 2001. Paper collage and acrylic paint on card, 17 x 28.5cm (6¾ x 11¼in).

Battersea Park Adventure Playground 3, Ann Manie, 1992. Paper collage and acrylic paint on board. 33 x 39cm.

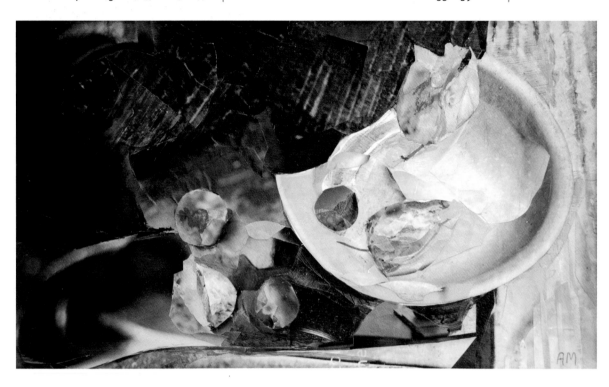

The language and style of Cubism and Surrealism have been important influences on my work. They provided freedoms: no more measuring of precise proportions and creating perspective horizon lines; art does not have to be an exact representation of the world. The flattening and distorting of objects and space on the picture plane together with the use of collage unleashed exciting possibilities. The language of Cubism together with Surrealism, which explored unconscious states of mind, have pushed the artistic boundaries for figurative artists like myself in the late 20th-Century and beyond. The collages shown here were executed over several years, and have been chosen with the intention of demonstrating the versatility of the medium.

The ideas for my collages are generated from small observational drawings and paintings of different subject matter. I only commence work after much analysis and thought as to how an aspect of something could be expressed in collage. An initial structural line drawing setting out overall shapes is made onto a board primed with white acrylic gesso, followed by light-coloured acrylic washes which enable key decisions to be made as to the overall tone and mood of the

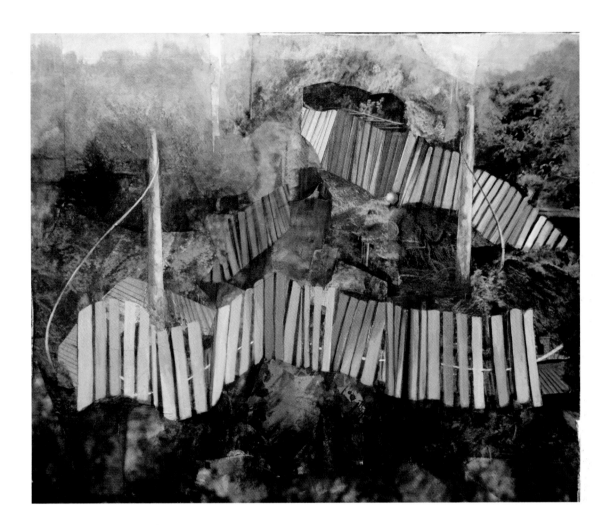

picture. A paper palette is prepared, in general using pieces of paper cut out from magazines. The colour, the tonal values and often the textural quality of the papers are of primary importance and play a major role in amplifying the underlying qualities of the chosen subject.

Photographs of people or specific places are not consciously included in the selection of paper fragments, but they sometimes reveal themselves when the work is finished and are, in some instances, eerily relevant to the subject and relate to a topical current event; a face, a person, an artefact or a building sometimes also lurk in the tonal area of a piece of paper, or an unexpected shape will just emerge of its own accord. *Battersea Park Adventure Playground 3* is a collage that essentially explores and contrasts nature and manmade structures. Sunlight, trees and bushes merge and interact against quirky, manmade, wooden-slatted spiral walkways, and swings convey a sense of playfulness, rhythm and, without the presence of children, mystery.

When I finished the work I put it aside and, some years later, I showed it to someone who spotted a ball floating in the air which I had not been aware of when making the collage.

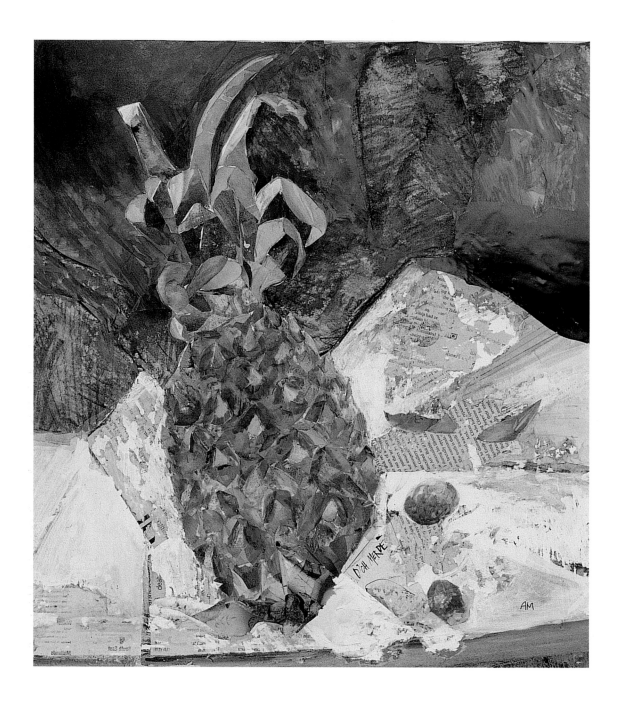

MIXED MESSAGES | THE VERSATILITY OF COLLAGE

Pineapple, Ann Manie, 1998.
Paper collage and découpage,
44.5 x 40.5cm (17½ x 16in).

Crushed Paper, Ann Manie, 1987.
Paper collage and acrylic paint on
board, 48.5 x 61cm (19 x 24in).

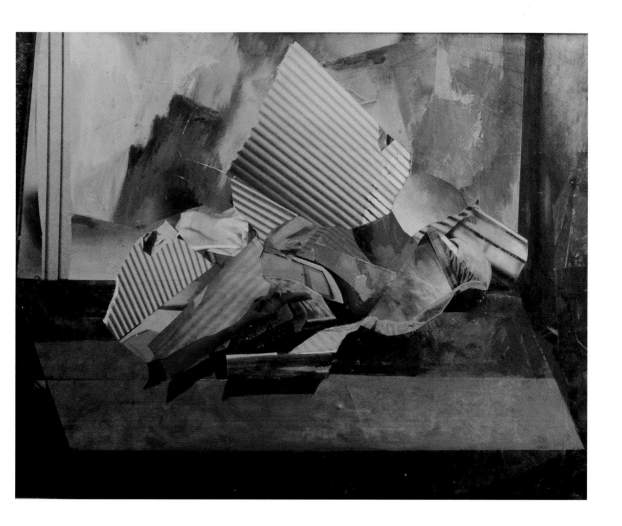

Objects in Sunlight, Ann Manie,
2005. Paper collage and acrylic
paint on card, 48 x 41cm
(19 x 16¼in).

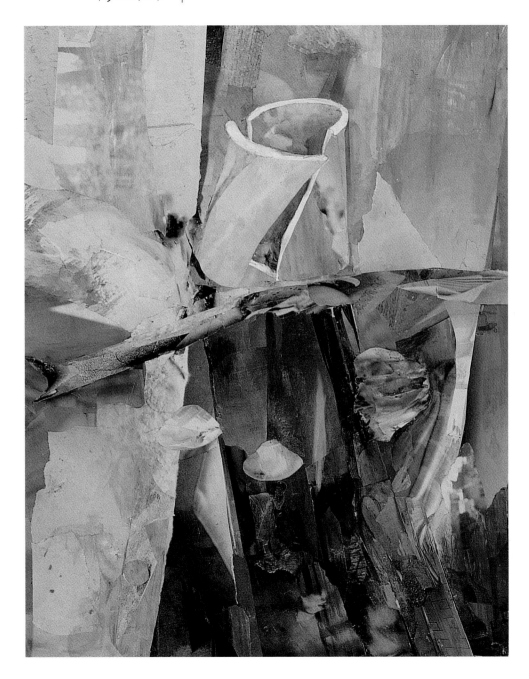

Arabic Coffee Pot No.1, Ann Manie,
2009. Paper collage and acrylic
paint on card, 46 x 35cm
(18 x 13¾in).

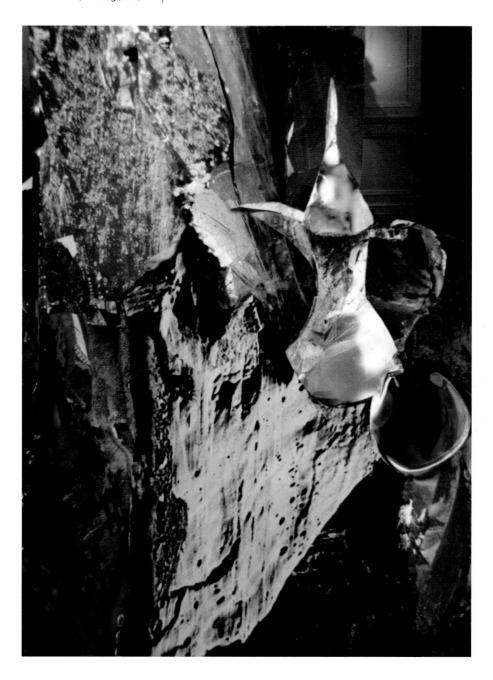

The person remarked that there were no children or people in the scene, so who could have thrown the ball into the air? The solitary ball evoked a conversation on the subject of two young girls who had suddenly vanished from their town in Cambridgeshire, England on a sunny afternoon. No one had seen them leave and everyone was frantically searching for them. The event featured every day in the media for several weeks and drew enormous attention and awareness to the vulnerability of children.

The idea of the observer seeing something in the work that I had not consciously intended is something that has intrigued me over many years, and I subscribe to the view that the spectator's role is as important as the artist's in the appreciation and assessment of an artwork; questions and revelations arise from the spectator that are quite separate from the artist's specific intentions when creating the work. The medium of collage seems to increase the chances of a viewer seeing and experiencing something beyond the purely representational aspects of a picture.

The unconscious reflection of a topical event is quite common in many artists' collages. The artist does not have total control over the outcome because there are often images that are subtly embedded within the piece of cut-out paper. This notion is echoed in the words of David Risley: 'A cut cannot be undone. You either accept the serendipity or discard the mistakes – which engenders a mood of contingency, a lack of total control and a respectful regard for the ad hoc. Perhaps this is why collage is aligned with radicalism: it shuns institutional control and subverts expectations – even the artist's.'[17]

Stonehenge, Roy Ray, 1985. Mixed media, 92 x 92cm (36¼ x 36¼in).

Coastline, Roy Ray, 2004. Mixed media, 59 x 59cm (23¼ x 23¼in).

ROY RAY

Roy Ray settled in St Ives in Cornwall in 1974. At that time he was a figurative painter but gradually over the years he has created constructions and collages which reflect a unique spiritual response that captures the intangible, underlying, mysterious qualities of the Cornish landscape. He employs a variety of tactile materials in his collages, such as MDF board, plywood, acrylic, sacking, paper and perspex. Roy uses a range of colours which are carefully mixed, producing a variety of subtle tones. Many of his collages comprise powerful contrasts, with delicate tonal harmonies working alongside slashes of strong colour.

The balance of colour and tones is intertwined so skilfully with the collaged areas that one has difficulty in distinguishing which is paint and which is collage. I have often viewed Roy's work from the outside looking in at street level in St Ives and London. Looking through the gallery windows and across to the walls where the pictures are hanging I sometimes speculate, 'Are they paintings or collages?' From a distance their surface quality appears smooth, delicate and painterly, but on closer examination the pictorial illusion is dispelled – it is collage!

Evilution: Where Their Footsteps Left No Trace, Roy Ray, 2010. Mixed media, five panels, 153 x 61cm (60¼ x 24in) each. Placed side by side (from left to right): *9/11, Hiroshima, Coventry, Dresden, Auschwitz.*

In 2000, Roy began to make a series of collage and mixed-media constructions, comprising five panels, entitled *Evilution: Where Their Footsteps Left No Trace.* This work is Roy's personal response to 'the evil brought about by advancements in science and technology and the innocent victims of conflict, many of whom were in the wrong place at the wrong time'. The muted tonal range of the colours and collaged artefacts and textures is powerful in describing the consequences of war and terror; it is the absence of people and

the fragmentation of manmade artefacts that is chilling. The style is recognisably Roy Ray but, unlike his earlier works, the subject matter is less abstract; country, location and objects are clearly recognisable.

The five panels are a memorial to the innocent victims of conflict and span a period of 70 years. From left to right, the most recent is the destruction of the World Trade Center in New York on 11th September 2001; followed by the atom-bombing of Hiroshima; the bombing of the city

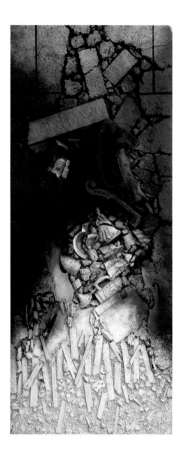
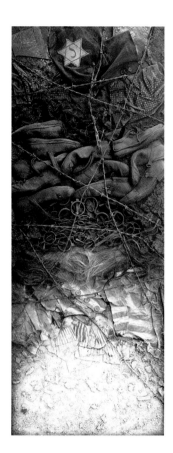

of Coventry; the bombing of Dresden; and the extermination camp in Auschwitz.

On a superficial level, each one depicts the consequences of war and acts of violence at a particular time and place, but they also contain a deeper psychological message that is contemporary and universal about humankind's capacity for blind unreasoning hatred and destruction using weapons that have evolved from advancements in science and technology. Roy underscores this last point by remarking, 'We split

the atom and made bombs, and poisonous gases were created and used with destructive intent in the First and Second World Wars.'

The five panels are only part of the ongoing *Evilution* project. *Sad Harry* is a collage about a soldier in the First World War who is shot at dawn for supposedly attempting to desert his post. The theme is the same – war, destruction and loss – but in this case it is small-scale and personal. The photo and perspex pieces are held in place by little stilts, and the transparent layering creates depth

Sad Harry, Roy Ray, 2009.
Construction, mixed media,
18 x 18cm (7 x 7in).

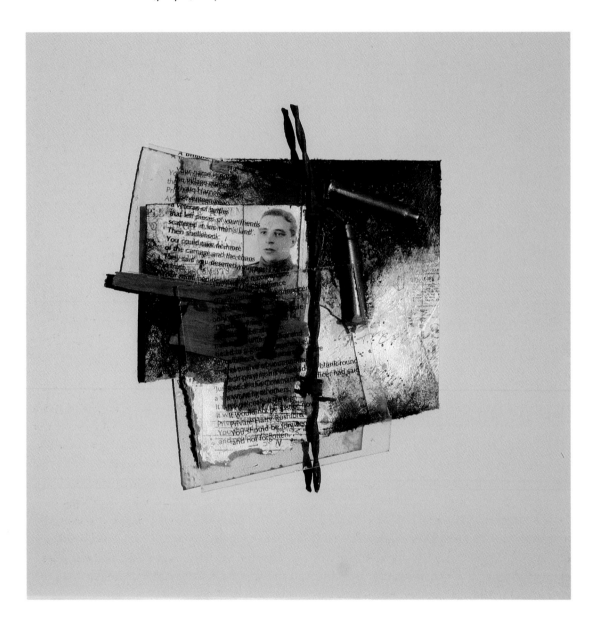

The author with Roy Ray in
St Ives in Cornwall.

and amplifies the poignancy and waste of war. The medium of collage – the art of attachment – in this case is integral to the poetic expression of the subject matter. We are drawn to Harry's face, and his plight, as we gaze at his photo through the layers of perspex and attached fragments of gun cartridge, wood and barbed wire.

The source material for Roy's *Evilution* is drawn from many areas of personal experience. As a child in 1940 in hospital in Middlesex he survived its bombing; during his period of National Service in 1957 he witnessed the nuclear explosion on Christmas Island; his grandfather fought in the Boer War of the 1890s and later in the First World War at the Battle of the Somme before becoming a Chelsea Pensioner; his father fought in the Far East during the Second World War.

In reflecting on his creative motivation in regard to the *Evilution* project, Roy is quite explicit about the personal nature of these powerful pieces of art: 'The works and poems were triggered by wartime childhood memories and have become my personal response to those times.'

ANGELA
RUDGE-LITTEN

Angela Rudge-Litten was born in St Albans, Hertfordshire, England in 1943. As a teenager she lived in Kingston-upon-Thames and attended Kingston College of Art, where she became deeply inspired by the painting technique and subjects of the 19th-Century French artist Henri de Toulouse-Lautrec, especially his depiction of the lively, elongated female dancers who performed in Parisian music halls at the time. Working mainly in the medium of paint thinly applied with sable brushes, as Toulouse-Lautrec had done in the 19th Century, Angela produced a sizeable portfolio of work in this genre during the early 1960s. At the age of 16 she exhibited a portrait of her father in this style at the Royal Academy Summer Exhibition and, as a result, was invited to attend the Royal College of Art in London when she turned 18.

Her artistic career continued to flourish as a student at the RCA during the early 1960s, a period she describes as 'varied and exciting', where she pursued her early passion for portraiture and the human figure at the same time as absorbing all manner of new artistic influences. One of the tutors at the Royal College was Sandra Blow, who at that time was a mixed-media abstract artist producing collages using hessian, sacking and sand mixed with thick oil paint. Exposure to Blow's collages and the work of the emerging Pop artists, especially those using collage such as Peter Blake (who had begun to explore the medium during the mid-1950s), together with the popular revival of interest in Cubism and all the pictorial possibilities it had to offer, provided a heady mix of artistic resources.

Angela continued with her interest in the human figure as well as animals, but the influence of Cubism became apparent in her work during the 1960s and for many years afterwards. Figures and objects are simplified and defined in broad areas of contrasting flat colours, similar to the Cubist artists, so that space is tipped up or flattened as traditional perspective was abandoned. Indeed, cubism and the pictorial devices associated with this technique were to have an enduring influence on her development as a painter.

It was later that Angela ventured into the medium of collage. The *Vampire Cat* collage is the result of years of experience as an oil painter combined with a deep knowledge of Cubism. With characteristic sincerity, brevity and modesty, Angela offers us an insight into her rich and diverse world: 'I was inspired by seeing our cat ferociously attacking a rag doll, and also by a Japanese print illustrating a two-tailed 'vampire cat' devouring a woman. For the collage I used paper from large street posters and various magazine illustrations.'

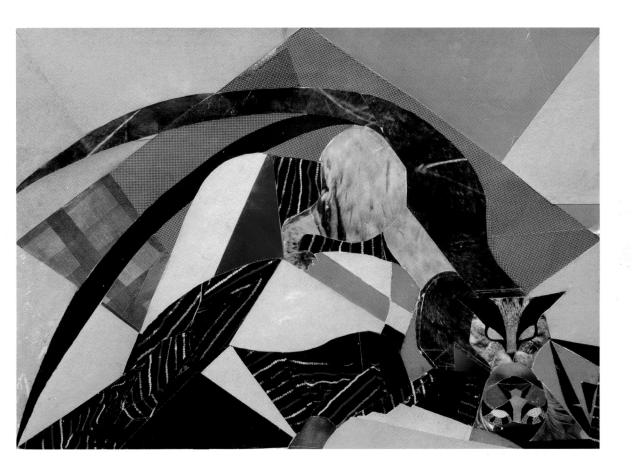

One can trace the elements and influences that make this work unique to Angela. The first is the aspect that reveals a figurative painter, namely, the desire to represent action and emotion using recognisable imagery, with her cat becoming enraged and the other is her interest in Toulouse-Lautrec (Toulouse-Lautrec's ladies were often depicted in similar states, devouring or being devoured by the world). The pictorial language, medium and technique reveal Cubism, Pop art and 1960s *Nouveau réalisme*.

Although collage is not Angela's preferred medium for her own work, as an art tutor, she has enthusiastically supported the use of the medium by other artists.

STEVE SABELLA

Steve Sabella is Palestinian and was born in 1975. He grew up in the Old City of Jerusalem in a Christian family but in the Muslim Quarter of the City. The memories of experiences of everyday life as well as social and political events that took place during his childhood and early teenage years have had a powerful impact on him and his development as an artist. The image shown here is one of a series entitled *in exile*, about personal loss, confusion and alienation.

The origins of *in exile* can be traced back to the perception that the Jerusalem he was born into 'disappeared'. He explains:

In 2004, the Jerusalemite artist Kamal Boullata (an artist who lives in exile), in a review about my artistic experiences, pointed out that he considered me an 'artist in exile' even though I lived in Jerusalem. It took me some time to become conscious of the essence of his words. I realised that I was not physically in exile, but rather, I was going through a process of mental alienation leading to a unique form of mental exile. I felt I was exiled in my own city of birth, which I started to perceive and see as a foreign land. Yet this was unsatisfactory to explain a state of fragmentation, dislocation and confusion that 'true' exiles go through. It had more to do with a 'reality' on the ground that triggered my state of mind. It could only be explained that I was somehow no longer living in Jerusalem. I was not physically in exile; it was rather Jerusalem that was exiled. Consequently, all those who live in Jerusalem have to feel out of place and alienated.

Steve further explains that *in exile* was triggered by a desire to find out where he belonged, and that the series represents 'reconstructions of the cityscape that belongs in my brain'.

Steve began working on this series in 2007 when he had just arrived in London. The city and its surroundings were unfamiliar, echoing similar sensations to those that he had felt in Jerusalem: 'The unfamiliarity heightened my sense of alienation, and I wanted to express how it feels to be in this permanent mental state.'

This subject is a closed window where one can only look out; there is no visible invitation to connect to the outside world. He has photographed the same window from five different angles using a digital camera. He decides the scale of the picture at the beginning and then the photographic images are haphazardly reproduced on the computer screen, which Steve explains is his 'canvas'. He then throws them around, multi-layering, cutting and pasting electronically, until a form shapes itself which, he says, mirrors his state of mind. The absence of a focal point in the image amplifies the feelings of loss and confusion that being in exile engenders. When the piece is ready it is printed and mounted onto an aluminium sheet.

in exile, Steve Sabella, 2008. Lambada matt print mounted on 2mm aluminium with a 5cm (2in) aluminium edge, 136 x 125cm (53½ x 49¼in), limited edition of six plus two artist's proofs.

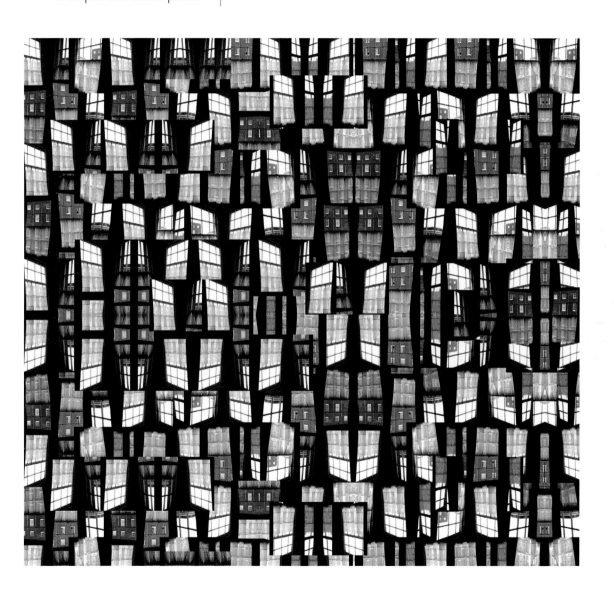

Steve says that his work is made up of two aspects, which taken together he defines as a 'form of Cubpressionism', perhaps reflecting the recurring, complex human dilemma which finds a powerful voice in his photographic collages. 'There is Cubism in the geometric multi-layering – the overlapping and interlocking shapes are geometry by intuition, a visceral geometry – and Abstract Expressionism, which reflects my inner feelings. In this instance the window is a good vehicle for expressing this: there is the original place and the new place – inside and outside. The duality of exile: you do not belong to the original place and in the new place feel out of place.'

He elaborates with another point that is important to the window series: 'I did the photomontage from the inside, mirroring myself, and at the same time you have the outside connotation of the world and how one is perceived by others.'

Steve Sabella studied art photography at the Jerusalem School of Photography and New Media in 1994. He gained a BA in Visual Arts in 2007 from the State University of New York. In 2008 he completed an MA with Distinction in Photographic Studies from the University of Westminster and then in 2009 studied for a second MA in Art Business at Sotheby's Institute of Art in London. He was also awarded the prestigious Ellen Auerbach Award (2008) granted by the Academy of the Arts in Berlin. His work has been shown and reviewed internationally and he frequently gives art talks and presentations in universities in England and Europe. Steve Sabella's artwork has attracted media attention and has been included in TV and film documentaries.

FATMA SAIFAN

Fatma Saifan is a student at Sheikh Zayed University in Dubai. She has exhibited in several group shows in and outside the United Arab Emirates (UAE), including the MIXCOLAB GROUP at the Bastakiya Art Fair in Dubai in March 2010. She describes her artistic motivation and the techniques used in the creation of her collage, *Under Construction*, as follows:

> Inspired by the landscape of Dubai, from the constant change and the vivacious energy of our urban city, in this series I combine symbols and imagery of traditional structures with ones that are more contemporary. We see these structures rising together side by side, creating the interesting cityscape. I find the contradictions created as a result of modernity over Dubai to be significant factors that are shaping the constantly changing landscape of the city. By mixing different artistic mediums I am mimicking the different forms of diversity that are found in the city. I combine different techniques such screenprinting, painting, collage and Chinese painting. While working on this series I've looked at the work of two artists from the 20th Century whose work has influenced my artistic style. One of

Under Construction, Fatma Saifan, 2009. Mixed media: collage, acrylic, screenprint, pen and mounted on hardboard, 76 x 61cm (30 x 24in).

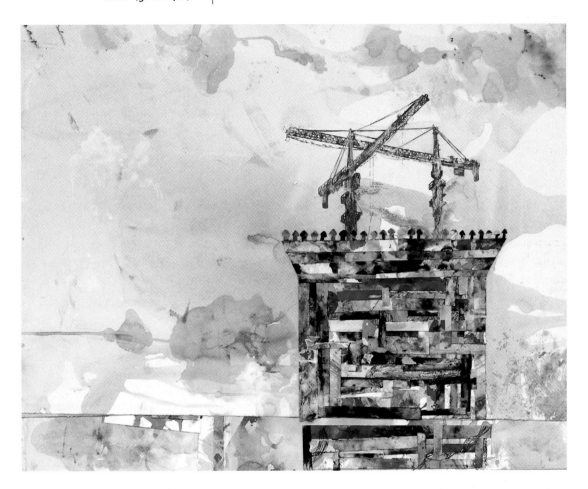

them is Western and the other is from the Far East: the American painter Jackson Pollock and the Chinese painter Wu Guanzhong. Fluidity, spontaneity and simplicity are what I got to appreciate from their art and I attempted to reflect this in my work.

Fatma Saifan was born in Dubai in 1988 and has so far lived her whole life there. Her *Under Construction* collage reflects the circumstances of her life to date. Building and cranes have been a common sight for several years in this prospering region.

RASHAD SALIM

Rashad Salim was born in 1957 in Sudan and is of mixed nationality – his mother was German, his father Iraqi and a diplomat, which meant that the family travelled extensively courtesy of the diplomatic service and were resident for periods of time in different countries in both East and West. Spending time in different countries during his early years was to influence his artistic practice as an adult. He describes his childhood with the following words: 'From an early age I experienced East and West, urban and nature, mountains and towers, enjoying beauty and function.'

Rashad is a sculptor and painter. He has created a stairway that initially grew out of a practical need to extend his working space. When he arrived at his current studio he discovered it had a mezzanine level, but there was no access, so he built a stairway from ground level to reach it using all the discarded materials that were around him; these comprised mainly shipping boxes used to freight his possessions to the UK from the Yemen from where he had recently been living.

Intriguingly, as he began constructing the stairway, possibilities emerged that were not envisaged at the outset. The idea presented itself that shelving, ledges and worktops could be attached to the ascending steps. He was creating something that was not only functional but beautiful and meaningful in its own right. The shelving enabled him to showcase artefacts that were important to him, especially gourds he had brought from Yemen and Morocco. Rashad explains: 'The shipping boxes and their contents are transformed from an obstructive presence to a constructive presence. 'The stairway has become multi-purpose: it is a passage, a place to store things, a display area and a work surface. There is a fluidity of space that inspires and intrigues me. Nothing is pre-planned – spaces and shapes occur organically as I work.'

The motivation for making a stairway began as something purely functional but over time has become more complex. The stairway has triggered memories of different cultural experiences and stirred his creativity. He elaborates: 'The stairway makes me think of two things: a tower and a mountain.

Stairway construction, Rashad Salim, 2010. Found objects.

Detail of shelf with gourds from *Stairway Construction*, Rashad Salim, 2010. Found objects.

There are similarities between a tower and a mountain: both have a passage of water – the water from the mountain flows down and the water in a tower pumps up. The mountain works with natural logic, with the order of the elements – gravity and matter; and the tower works with order imposed on it.'

The Dada collage artist Kurt Schwitters constructed a column out of discarded materials in the middle of his house, extending from the ground floor to the top floor, which he called a *Merzbau* (see Part One). Rashad's stairway invites comparison to the *Merzbau* because the assemblage accesses higher space within an interior and the materials stem from a similar source. I asked him how his stairway differs from or is perhaps similar to the *Merzbau*: 'Kurt Schwitters's *Merzbau* was more of a tower, where human order is imposed. My stairway is about trying to regain the sensibility of the mountain within the tower. The culture of mountains which I experienced in Yemen and Morocco is an inspiration that has become embedded within the stairway. The mountain culture not only has natural channels for the flow of water, but it has mysterious paths and trails where humans can pass. It is functional and beautiful.'

Rashad regards his stairway as an assemblage that is bringing all his lifetime influences and personal needs together: East and West, urban and nature, mountain and tower, function and aesthetics and spiritual fulfilment. He concludes our discussion about the stairway with the following remark: 'I am searching for a unity, finding the life within a piece of art.'

Rashad's stairway reflects history, nature and mankind. Like the Dadaists he uses the 'found object' to make a piece of art. His life experiences, his actions and words have led him to the culture of the mountain that has always engaged human beings in some way – through its scale and mystery. Mountains do not necessarily occupy the consciousness of most people, especially urban dwellers of the 21st Century, but they have found expression in the work Rashad Salim through the medium of assemblage/collage.

Ida, Tamsyn Williams, 2010. Cardboard, paper, acrylic, fabric and charcoal, 57.5 x 49cm (22 x 19¼in).

Kitchen, Tamsyn Williams, 2010. Cardboard, paper, acrylic, fabric and charcoal, 43 x 36.5cm (17 x 14in).

TAMSYN WILLIAMS

Tamsyn Williams was born in 1958 in Cornwall and, apart from leaving to study in Oxford and London for a few years in her twenties, she has lived there most of her life. She is very involved with green issues within the community and the environment. This is reflected in her working practice as a collage artist. As Tamsyn explains, 'I like the fact that most of the materials I use in my collages, such as discarded paper, board and other artefacts, are playing a recycling role.' Indeed she insists that 'All I need to buy are paint, glue and frames.'

The primary source of artistic inspiration comes from her tall rambling terraced house, situated on a slight hill in St Ives in Cornwall. The house is magical, with a small lush garden and a quirky interior: rooms lead into rooms and out onto landings with narrow staircases that take one higher into a magnificent sunny spacious loft area which is her studio. One is transported back to another century pre-dating the invention of plastic and other technological inventions, to a simpler way of life where 'recyling' was not an identifiable social issue and things were not so readily discarded, but were rather reused or handed down.

Tamsyn's collages are made up of layers of recycled paper, board, various furnishings and things that matter, or have mattered, in her life. When collaged together they create a lively

Home, Tamsyn Williams, 2010.
Cardboard, paper, acrylic,
fabric and charcoal, 17 x 40cm
(6¾ x 15¾in).

Tamsyn's palette.

interplay of colour, texture and spatial depth. Walls, doors, windows and other openings are subtly alluded to in the pictures, conveying the essence of her Victorian terraced house.

The collages hover in a corridor between figuration and abstraction – there are some allusions to artefacts from the recognisable world and conventional space, and yet the overriding sensation is a celebration of the aesthetic beauty of the materiality of paper and card, which has touches of thin layers of paint here and there.

The technique and semi-abstract quality achieved is very similar to Robert Rauchensberg's collages of the mid-1950s. Rauschenberg was renowned throughout his life for his commitment to social concerns, and the discarded objects he represented in his work would often reflect the flip side of consumer capitalism.

Tamsyn confirms that he is one of many artists who interest her, although her own artistic concerns are different. At the moment these are about the layers of history and the changes that have occurred in one particular place, as revealed, for instance, in the successive layers of wallpaper that chronicle the decorative history of her Victorian terraced house.

Tamsyn explains that collage is the perfect medium for this subject matter as it is technically a multi-layering process: cutting and pasting, changing things, covering up or partially covering up areas, overlapping different papers and adding paint in order to engage with and express 'the aged quality of the place and the things that were there before'.

There is an extra twist to Tamsyn's multi-layering working technique and interests – her palette. Often a discarded piece of hardboard with a residue of coloured dabs of paint relating to a previous collage becomes the basis for another collage, and so the recycling process continues.

Of her work in general Tamsyn remarks, 'I love my paintings to be dirty, full of texture and messy, and the process of making them should be revealed.'

However, the results seem to me to contradict the personal desire for there to be a 'dirty' and 'messy' quality, revealing instead collages that have a soft, subtle and delicate harmony, with a whiff of mystery. This to me is reminiscent of two more of Tamsyn's favourite artists: the 19th-Century French post-Impressionist painters of interiors, Pierre Bonnard and Édouard Vuillard.

3

PART THREE:
INTRODUCING
MATERIALS
AND TECHNIQUES

This part introduces materials and techniques which I use for creating a collage, together with some advice on conservation and framing. Two still-life collage demonstrations are described, which reveal features of Cubism: one with black, white and grey tones, and the other in a limited colour range. There is also an introduction to intaglio printmaking with demonstrations on how collage is incorporated into this medium (together commonly referred to as chine collé), using landscape as the subject matter.

THREE-STAGE
PROJECT:
STILL-LIFE

A still-life subject matter with recognisable objects is a good starting point for a piece of collage artwork. Once there is a familiarity and engagement with key aspects of picture making such as line drawing, composition, shapes, tones, colours and materials, then one can move on more easily into expressing abstract ideas. There are many experienced artists who would agree with the notion that one develops originality by visually observing and drawing shapes, colours and textures that exist in the visual and tactile world. Consciously and subconsciously the human brain (assisted by the eye, hand and sketchbook) builds up a memory bank of 'visual images' that represent a unique interpretation of the tactile world which can be used as source material when one moves on to create and express more abstract ideas. Drawings and paintings do not have to be executed in perfect proportion or perspective in order to be useful as source material for future pictures.

Naturally, there are always situations where a knowledge and expertise of proportion and perspective are key to a successful outcome, such as in portraiture or *trompe l'œil*. However, once one starts working on a collage, the conventional rules of proportion and perspective seem to be bypassed. After a while one notices that collage creates its own rules and constraints: lines, colours, textures, surreal shapes and spaces occur in the juxtapositioning of different pasted papers onto a surface (especially when using paper from magazines). Strange, wonderful and exciting things happen that cannot be envisaged at the outset!

When commencing a collage it is advisable to keep the subject matter simple and limit the choice of materials and colours. For this project the style need not necessarily reflect the techniques of Cubism, but some of the pictorial devices, such as the use of flattening and the distortion of objects and the space they occupy (either foreground, middle-ground or background), could be useful in releasing tension or anxiety with regard to the conventional notion that an art class should begin with producing an exact likeness of what one can see.

STAGE 1 – STRUCTURAL COMPOSITION

Viewing frame made from
picture-framers' mount card. >

Start by selecting a composition. A useful aid is
a viewing frame, made by cutting out a square
from a separate blank sheet of paper or card. Look
through this frame and identify shapes and lines
that occur within it: circular, square, rectangular,
linear, etc.

Thumbnail sketches to aid
 composition of picture. ∨

Make a few quick three-minute drawings on a sketch pad of what you can see through this frame as you place it around the still life and area of the room in which it is located. Is it intriguing viewed from above or below? Part of a still life where the objects are only half-shown could be interesting, as is revealed in the paintings of artists from the late 19th and early 20th Centuries. This technique, commonly known as 'cropping', can be seen in the paintings of Edgar Degas, Édouard Manet and Paul Cézanne – people, space and objects are partly depicted at the edge of the canvas, thereby implying a space and activity that extend beyond the painting. Some examples

are included in *The Age of the Impressionists* by Denis Thomas, *Cézanne*, with explanatory text by Elizabeth Elias Kaufman, and E.H. Gombrich's *The Story of Art*. Later, the still-life pictures by Cubist artists such as Pablo Picasso, Georges Braque and Juan Gris also reveal this feature. *Cubism* by Neil Cox and *In Defiance of Painting* by Christine Poggi are good sources of information which showcase pictures featuring this compositional element as well as providing an in-depth analysis of the more complex pictorial devices thought up by the Cubists.

STAGE 2 – BLACK AND WHITE TONAL COLLAGE

Types of working surface for collage: white, grey and beige cartridge paper and card. ∨

Working in black and white monochrome enables one to quickly engage with the subject. Many artists past and present use this as a tool to decide on the overall mood of a picture before commencing major works in colour. You could look at examples of tonal paintings and drawings by famous artists of the past such as Rembrandt (*Rembrandt Drawings*, Dover Publications, 2007) and Goya (*Great Goya Etching*, Dover Publications, 2006) and recent tonal artwork in *The Drawing Bible* by Marylin Scott. Identify the lightest and darkest areas of the composition followed by the middle tones. The process of limiting the choices allows the beginner to commence with a degree of speed.

Paper palette: a range of blacks, greys and whites, glue, brushes. >

Start with a line drawing. ⌄

The line drawing with a
wash of acrylic paint applied
in black, white and grey. ⌄

Draw out in line, loosely and quickly the overall composition. The working surface for the collage should be moderately firm, cartridge paper, light card and hardboard that has been primed with gesso or white household emulsion paint are all suitable. Canvas is not advisable as it is too soft a surface for pasting paper and other artefacts on to. PVA glue is a good adhesive, it is strong and adheres to hardboard, paper and card

fairly well and is quick drying. It can be used in concentrated form, or diluted with water, 1 part PVA to approximately 4 parts water creates a reasonable-strength glue.

Continue to observe the chosen subject and identify the light source. Is there a single light source creating strong shadows and contrasts of darks and lights? Or is the composition evenly lit with tones that are evenly spaced?

Collage paper glued over the wash. ∨

The final collage. ∨

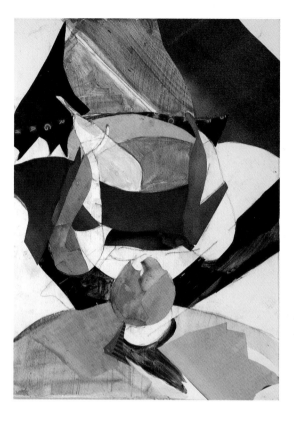

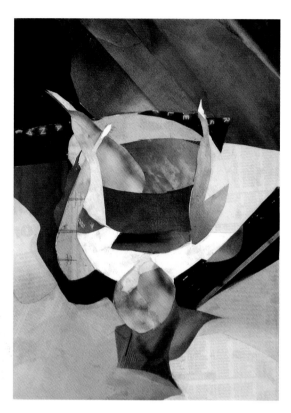

Select three to four contrasting grey tones, and perhaps black and white, from the range of cut-out papers – newspaper is very good source material for this exercise. When making a selection, ignore any photographic imagery or text on the paper: the aim at this early stage is to create a picture in tones of black, grey and white. As the picture evolves, photographic imagery or text may subconsciously play a role, but this is incidental in the early stages. You may wish to eliminate the photographic images by lightly drawing or painting over them. This action can add depth and create richness, though I recommend you do this only when the picture is nearing completion. It is worth mentioning that if you pick three or four tones that are evenly spaced (i.e. neither very dark nor very light), the overall effect of the resulting image will probably be calm and peaceful. On the other hand, tones that have sharp and definite contrasts such as black, white and grey, will most likely evoke a mood of drama and unease.

STAGE 3 – COLOURED COLLAGE

Work in progress with materials: limited coloured paper palette, pencil, brush and glue. ∨

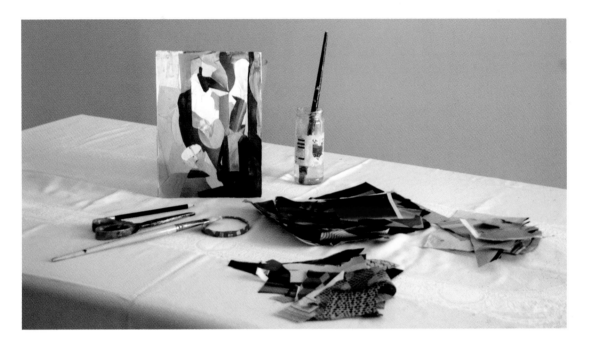

Select two or three colours as well as black and white. As with the previous exercise, use the viewing frame to identify an interesting composition and perhaps employ the techniques of the Cubist artists – represent different viewpoints in one drawing, overlapping and interlocking objects and space. Make small sketches of different compositions on a separate sheet of paper or in a sketchbook. Begin the collage by drawing out the main shapes of the composition on cartridge paper, card or primed hardboard.

Once the general drawing is complete (a hard lead pencil is preferable when drawing out the main composition), apply coloured washes using acrylic paint or watercolour to the large areas of the picture. Begin to paste the selected papers onto the surface; generally, it is preferable to work from large to small areas. Paint, crayon or other artefacts which may simplify or enhance the collage can be made at the final stages of completion.

Line drawing. ⌄

Coloured wash of
acrylic paint. ⌄

Collage paper glued
over the wash. ⌄

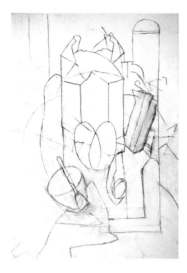

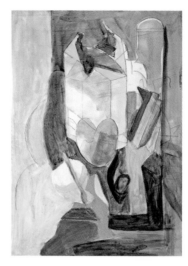

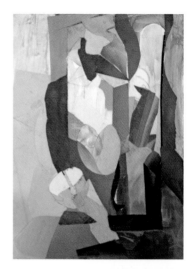

Final collage. >

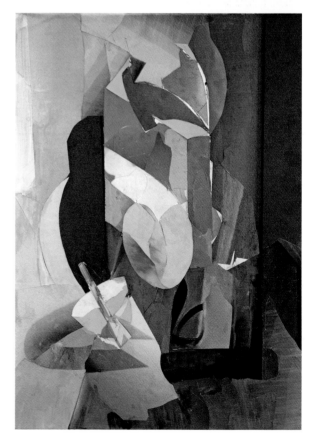

CONSERVATION

If you look closely at the collages of Pablo Picasso and Henri Matisse you will notice that the materials are cockled and creased. The artists themselves were perhaps fairly casual in their attitude to conservation, but as pioneers in the use of this medium they might be forgiven for not giving it too much thought at the time. However, two important aspects to think about when you have gained experience with paper collage and wish to create more developed pieces are conservation and storage.

With conservation, it is recommended that 'museum' card is used as a surface to work on. It is acid-free and, unlike ordinary card or unprimed board, will not burn or damage the paper of the finished collage over time. The card comes in different shades of cream and white and is available at most art shops. EVA glue is one of the best adhesives on the market. It does not contain harmful ingredients and is available from www. conservation-by-design.co.uk. Piers Townshend

at the Paper Conservation Department at Tate Britain in London advises collage artists not to use rubber cement or SprayMount. He explained to me that 'Such solvent-based glues are tempting because of their repositionability, but do not last long-term.'

Some artists 'seal' their work by coating it with a diluted solution of Evo-Stik Wood adhesive glue and water (10 parts water to 1 part glue), but you should try this first on a small corner of the collage to check for drying and effect before covering the whole piece. For storage, keep collages away from direct sunlight and in a dry place.

The finished collage should not be against glass as this can damage the work. Place a mount card over the border edges of the collage when putting it inside a conventional frame, or use a box frame so that the collage paper is not touching the glass. Non-reflective glass is also very helpful in preserving the work, but this is expensive.

CHINE COLLÉ

Materials: Charbonnel ink,
scrim pad and zinc plate
with image of *Coniston Water*
already etched into the metal. ∨

Chine collé originated in the Far East several hundred years ago and was used to enhance the surface quality of paper for printing woodcuts, by adding one sheet of paper to another in the impression process. However, the principle is used by many printmakers for pictorial reasons: paper is pressed onto a handmade print, allowing the subtle tones of the collaged paper to enhance the delicacy and add depth to the printed image.

A step-by-step demonstration of the processes involved in creating a chine collé print, from inception to completion, is illustrated below by Jason Hicklin RE (Member of the Royal Society of Painter-Printmakers)

The ink is evenly applied to the surface of
the metal plate with a rubber roller. ∨

A scrim pad is used to
wipe off the main areas of
unwanted ink. ∨

The final wipe is made with a
square of tissue to ensure that any
surplus ink is removed. ∨

The main printmaking papers are soaked in a sink of clean water for about 10 minutes – Japanese paper for the chine collé and the supporting Somerset Soft White paper (300gsm). These papers are then removed from the water and placed in between two layers of blotting paper to remove all excess moisture; this can be done in advance of inking the metal plate. ⌄

The 'inked up' metal plate is placed onto a sheet of tissue paper on the press bed. >

The dampened Japanese chine collé paper is placed over the plate (there is enough size in this paper to allow adhesion to the main Somerset paper.) ⌄

The main supporting Somerset paper is placed on top of the plate and the Japanese paper. ⌄

Blankets are placed over the plate and papers and then the press is slowly wound over these. >

When the press has been fully wound, the blankets are pulled back and the print is carefully removed by lifting up two corners with clean, white, small squares of folded paper: it is important to do this in order prevent any unwanted dirty marks appearing on the print. The damp print should be placed under a heavy weight (e.g. heavy books) for a day or so, to ensure that it dries flat and to prevent wrinkling. ∨

The finished print: *Coniston Water*, Jason
Hicklin, 2010. Etching and chine collé,
Japanese paper on Somerset paper,
27.5 x 57cm (10¾ x 22½in). ⌄

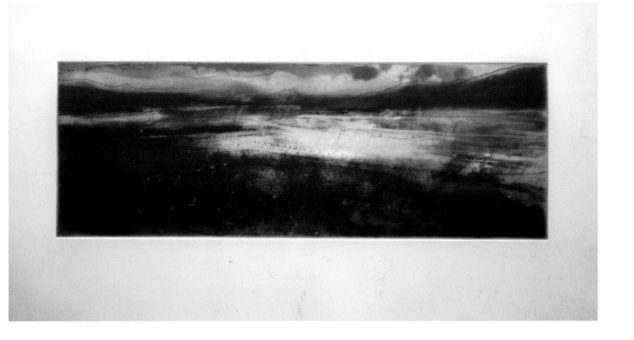

The illustrated demonstration is only a partial account of the printmaking process. There are many books available that provide comprehensive and detailed information on the centuries-old process of etching. Most notable among these are *The Thames and Hudson Manual of Etching and Engraving* by Walter Chamberlain and *Intaglio Printmaking* by Mychael Barratt, an A&C Black printmaking handbook. It is important to mention that chine collé printmaking is the combination of two media: collage from the 20th century, which is radical and unpredictable in outcome;

and etching, which has its roots in the Middle Ages and is associated with the earliest method of mass-producing printed matter.

I have used the method demonstrated above by Jason Hicklin to produce the following chine collé prints. These images explore the wonderful fleeting sensations of light, movement, texture and colour that occur at the Thames foreshore at different times of the year. However, instead of collaging with Japanese paper, coloured newsprint was used, with a light coat of PVA glue to attach it to the main Somerset paper.

Foreshore in March, Ann Manie,
2004. Etching and chine collé,
10 x 12.5cm (4 x 5in).

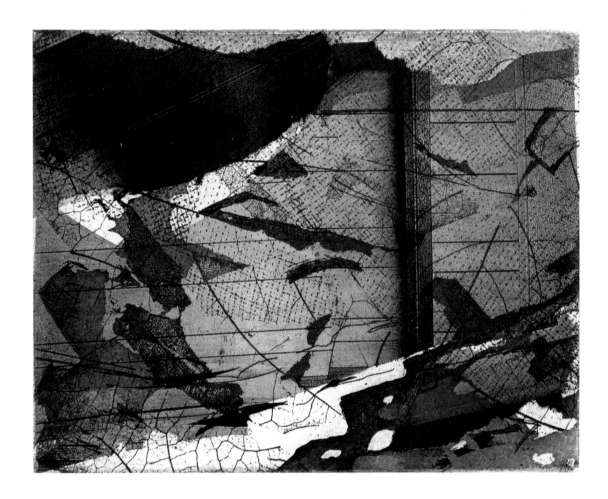

Foreshore in April, Ann Manie,
2004. Etching and chine collé,
10 x 12.5cm (4 x 5in)

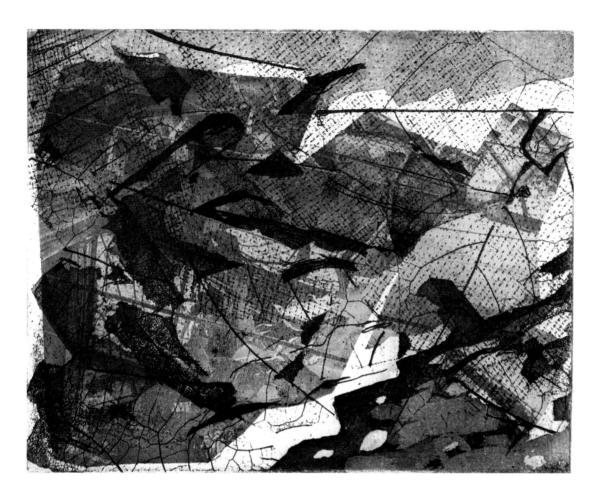

Further illustration of my own method is shown
in the pictures below:

Selected image:
overlay collage papers. ∨

The inked-up
etching plate. ∨

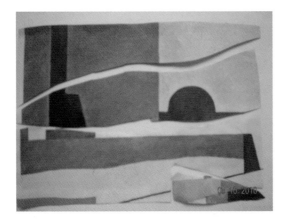

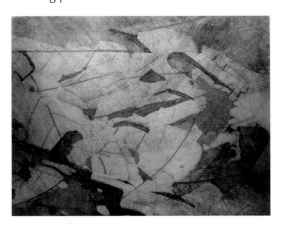

Transferring collage
papers onto the plate
(with the reverse side
face-up). >

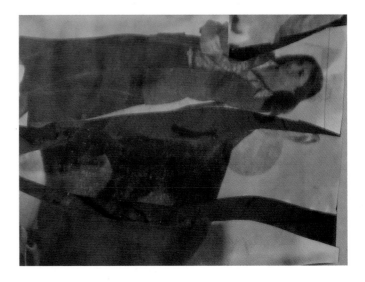

Positioning Somerset paper
over the collage papers. ⌄

The final chine collé ＞

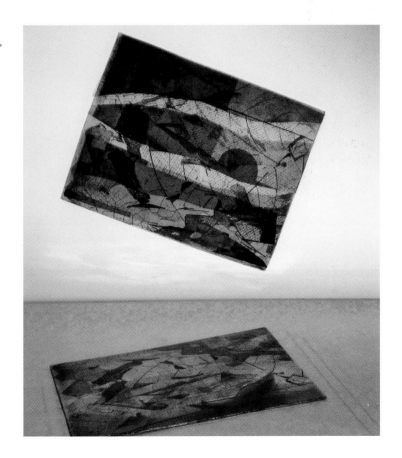

Further chine collé prints
from the same plate.

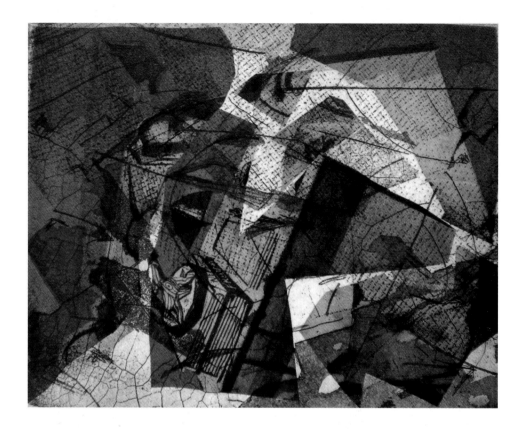

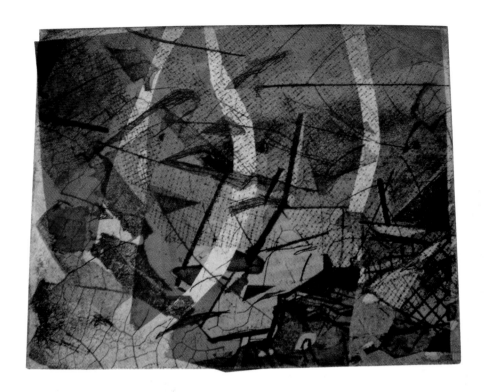

4

PART FOUR: PROJECTS

This part comprises four collage projects which vary in subject matter: (1) Landscape; (2) Reflections; (3) Metamorphosis and the found object; and (4) Pop art. Although the subject matter is varied, the techniques used in making these collages are similar to those described in Part Three. It is worth emphasising that what I outline below is the way in which I tend to work, and that other artists may adopt quite different methods. The purpose is not to be prescriptive, to give a rigid step-by-step set of rules (because creating artwork is not really like that), but simply to offer some ideas and suggestions. As any artist knows, the work will often take on a life and direction of its own.

4

Sketch of Dubai Creek.

1. LANDSCAPE

This subject comprises three basic variations – urban, sea or countryside – or a mixture of all three. Source material for the project could be created from drawings made in a sketchbook as well as from photographs. I have chosen a busy waterway (the Dubai Creek) that reflects history, nature and 21st-Century architecture. The source material is from drawings made in my sketchbook while walking along banks of the Creek.

Back in the studio, working from the selected sketch, the basis for a landscape collage is created by establishing the main spatial relationships, with areas of coloured washes applied over the drawing broadly to represent the foreground, middle-ground and distance. Considering location, coloured papers are selected in hues that correspond to the organic and manmade landmarks and overall atmosphere. I begin to apply the paper, covering the larger areas first and then adding and defining smaller shapes such as buildings and boats at a later stage.

STEP-BY-STEP APPROACH TO PRODUCING COLLAGE OF THE DUBAI CREEK

Dubai Creek – step 1. ∨

Dubai Creek – step 2. ∨

Dubai Creek – step 3. ∨

Dubai Creek – step 4. ∨

You can begin to see that paper collage is exciting, unpredictable and also versatile enough to work well with a wide range of subjects.

2. REFLECTIONS

Using reflections in the more literal rather than the abstract sense ('abstract' in this case meaning things that are not immediately recognisable) is the subject of this collage project. Light, whether this is natural or electric, can distort familiar, recognisable objects and spaces, whether in an interior or an exterior setting. The varying intensity of different lighting can play tricks with one's perception of reality; boundaries between what we think is real or not real can become blurred.

For example, when we look into a shop or café window we may think we are observing the shapes of actual people and tactile objects inside (people seated in furniture and surrounded by objects), then suddenly the images disappear,

the interior becomes blank, an empty space. The realisation dawns that the shapes and figures are reflections caused by the light from behind. There is a complete change of physical appearance, engendering a sense of intrigue and mystery.

In this example, I have again produced an initial tonal drawing from direct observation. In this case I was looking into the window of a bureau de change, where reflected images of palm trees and street architecture became mixed with the actual objects (books and pamphlets on the inside window ledge) behind the glass. The process is similar to that employed in the previous projects, but focusing more on shape, colour and tonal values, rather than just trying to depict recognisable objects.

STEP-BY-STEP APPROACH TO PRODUCING A COLLAGE ON THE THEME OF REFLECTIONS

Reflections:
Tonal drawing from
direct observation. ⌄

Reflections – step 1:
Line drawing establishing
spatial relationships. ⌄

Reflections – step 2:
Colour wash establishing overall
colour and tonal values. ⌄

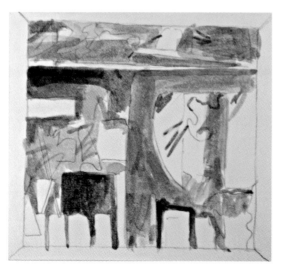

Reflections – step 3:
Commencing paper collage. ⌄

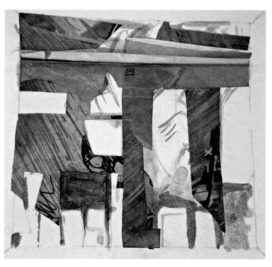

Reflections – step 4:
Completed collage. ∨

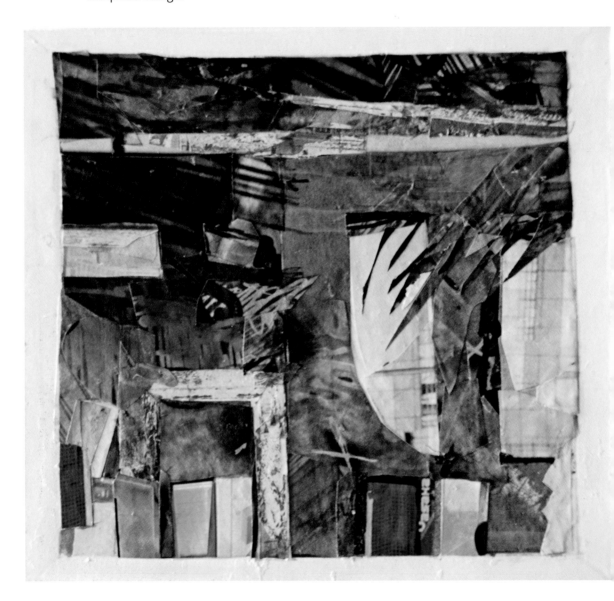

3. METAMORPHOSIS: CREATING A 'SURREALIST' PICTURE FROM A STILL LIFE OF FOUND OBJECTS

This project attempts to create a collage in the spirit and style of Surrealism from a display of objects. It begins by choosing some discarded items. In the example below I have used plastic ice-cream spoons, cartons and paper, along with shells and stones collected when walking. After drawing a composition in line, paper was selected: black, white and three colours. The paper was applied, working on the larger areas first, considering where the darkest and the lightest tones and colours should be. Once the main areas were collaged, the selected paper was allowed to dictate the drawing and direction of the picture. Interesting colours, shapes and surreal spaces began to appear that were not dreamed of at the beginning of the project.

Metamorphosis: photo of an arrangement of assorted found objects placed on a surface in my studio. ›

STEP-BY-STEP APPROACH TO PRODUCING A COLLAGE ON THE THEME OF METAMORPHOSIS

Metamorphosis: Exploratory
drawing of the arrangement
of found objects. ⌄

Metamorphosis – step 1:
Line drawing – establishing
spatial relationships. ⌄

Metamorphosis – step 2:
Colour wash establishing overall
colour and tonal values. ⌄

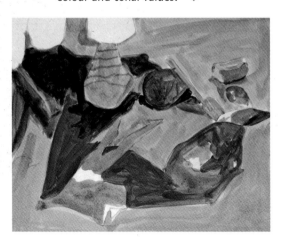

Metamorphosis – step 3:
Commencing paper collage. ⌄

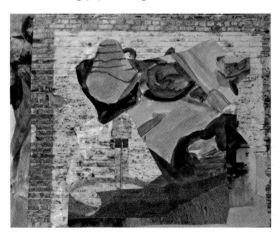

Metamorphosis – step 4:
 Completed collage. ∨

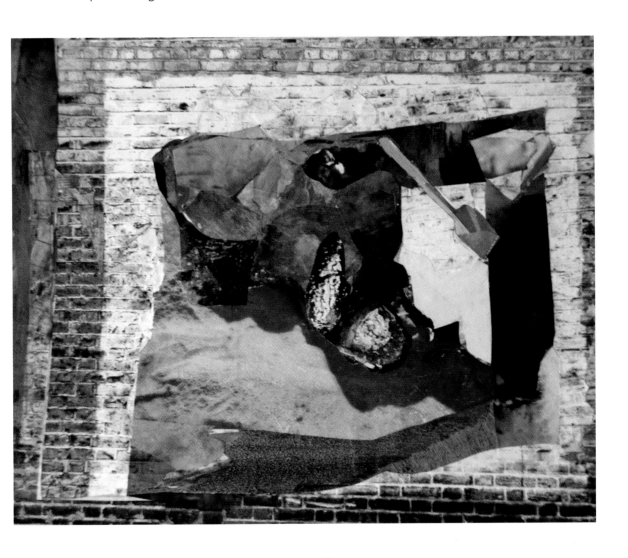

4. POP ART

The Pop artists took inspiration from all areas of popular and commercial culture. Their collages, as shown in Part One, were made from photographs and text cut out of newspapers and magazines. The subject matter embraced everything and everyone: politics, social events, entertainment, celebrities, scientific discoveries, technological and manufacturing innovations, fashion, sport and advertising of consumer products (edible and inedible, large- and small-scale).

You can create your own piece of Pop art by choosing a subject that interests you and cutting out a selection of pictures associated with it. Assemble the photos and possibly any relevant text and then paste these onto a firm surface such as a piece of card or board. There are no strict rules, so feel free to randomly apply photos, shapes, colours and lettering in any way you think suitable – allow for the unpredictable – for comical, intriguing and surreal effects!

Below is a piece of Pop art from inception to completion, inspired by the football World Cup in South Africa, which I have called *At the Match – 2010*.

STEP-BY-STEP APPROACH TO PRODUCING A 'POP ART' COLLAGE

At the Match: step 1 ∨

At the Match: step 2 ∨

At the Match: step 3 ∨

THE INCLUSIVENESS OF COLLAGE

This book has endeavoured to explain how collage evolved into a valid artistic medium and how artists today are still finding new ways of using it. Collage played a powerful role in the artistic journey from naturalistic representation to abstraction. In showcasing a wide range of collage artists from the past 50 years or so, alongside the illustrious early giants in the medium, I hope I have demonstrated that every artist learns and gains nourishment from the past as well as from each other in the present.

As a technique and a medium collage is versatile enough to be able to depict a wide range of subject matter. The mental and physical act of cutting, pasting and juxtaposing different papers containing a variety of colours, textures and shapes can sometimes expose a mixture of messages within one picture, some intentional and others unintentional. Whether intentional or not, the inherent eclecticism of the technique can lead to results that are often surprising, witty, powerful, even profound.

ENDNOTES

1 *Collins English Dictionary, Complete & unabridged new edition*, 2005, p.333.
2 Peter Blake in conversation with Natalie Rudd, *About Collage*, 2000, p.11.
3 Simon Wilson and Jessica Lack, *The Tate Guide to Modern Art Terms*, 2009, p.85.
4 Fiona Bradley, *Surrealism*, 1997, p.16.
5 Sigmund Freud, *The Interpretation of Dreams*, 1899.
6 Werner Schmalenbach, *Kurt Schwitters*, 1970, p.43 and p.135.
7 Brandon Taylor, *Collage: The Making Of Modern Art*, 2006, p.135.
8 ibid., p.162.
9 Blake/Rudd, p.21.
10 ibid., p.21.
11 Wilson and Lack, p.149.
12 Used by the Chris Ofili exhibition at Tate Britain 27 January–16 May 2010.
13 Included in the catalogue published to accompany the exhibition at Tate St Ives, *Sandra Blow – Space and Matter 1958-2001*. © Tate Trustees, 2001, at p.15.
14 Quoted in *'A tribute to Sandra Blow, 1925 to 2006, who died on Tuesday 22 August 2006'* and also referred to in Mel Gooding's essay (see note 14).
15 Courtesy Janet Rady Fine Art. Exhibition, London, 9 June–10 July 2010.
16 www.penwithprintmakers.co.uk.
17 David Risley in brochure for Collage exhibition, Bloomberg, 27 March–8 May 2004.

SUPPLIERS OF ART MATERIALS

There are many suppliers of art materials all over the country (and elsewhere), but the ones I have listed below are all in London.

ATLANTIS ART MATERIALS
7–9 Plumbers Row
London E1 1EQ
Tel: +44 (0)20 7377 8855
www.atlantisart.co.uk

BATTERSEA ARTS CENTRE
295–97 Lavender Hill
London SW11
Tel: +44 (0)20 7228 7271
www.bac.org.uk

GREEN AND STONE
259 King's Road
London SW3 5EL
Tel: +44 (0)20 7352 6521
www.greenandstone.com

INTAGLIO PRINTMAKERS
(Printmaking suppliers)
9 Playhouse Court
London SE11 0AT
www.intaglioprintmaker.com

JOHN PURCELL PAPER
(Paper suppliers)
15 Rumsey Road
London SW9 0TR
www.johnpurcell.net

GLOSSARY

ABSTRACT ART
An art form which is not dependent upon a fundamentally naturalistic approach to the subject matter for the expression of form, space and colour.

ABSTRACT EXPRESSIONISM
A form of abstract art which originated in America in the 1950s in which the artist combined sponteneity and the subconscious in the creation of the painting.

ACQUATINT
An etching technique in which a resin dust is added to a metal plate by heating it onto the surface of the plate. The plate is then dipped in acid, which only bites in areas between the dust particles, thus creating a tonal value on the plate. Originally developed to produce watercolour-type effects.

ACRYLIC PAINT
Paint comprised of pigment bound with a synthetic resin. Acrylic paints can be diluted with water and dry within minutes.

APPLIQUÉ
A decoration or trimming of one material sewn or otherwise fixed onto another.

ARTE POVERA
The term *Arte povera* was coined in 1967 by the critic Germano Celant to describe a group of Italian artists making work that used the simplest means to create poetic statements based on the events of everyday life.

ASSEMBLAGE
A three-dimensional work of art that combines various objects into an integrated whole.

AVANT-GARDE
Artists, writers musicians, etc., whose techniques and ideas are markedly experimental or in advance of those generally accepted.

CHINE COLLÉ
Fragments of paper collaged onto an etching for aesthetic reasons, to create subtle tones, shapes and colours. Chine collé originated in the Far East several hundred years ago where it was used to enhance the surface quality of paper used to printing woodcuts by adding one sheet of paper to another in the impression process.

COLLAGE
Derived from the French verb *coller* meaning 'to stick', collage is the technique of pasting cloth, paper or other materials onto a canvas or surface. It was first used by the Cubist artists.

COMPOSITION
The term applied to the arrangement of form and colour in a painting or other two-dimensional artwork.

CONSTRUCTIVISM
A movement in abstract art that evolved in Russia after the First World War. The Constructivists believed that art should directly reflect the modern industrial world. Vladimir Tatlin, one of the founder-members, was profoundly influenced by Pablo Picasso's Cubist constructions, which he saw in the Spanish artist's studio in Paris in 1913.

CUBISM

French school of painting, collage, relief and sculpture initiated in 1907 by Pablo Picasso and Georges Braque, which amalgamated multiple viewpoints of natural forms into a multifaceted surface.

DADA/DADAISM

A nihilistic artistic movement of the early 20th Century in Western Europe and the US, founded on principles of irrationality, incongruity, and irreverence towards accepted aesthetic criteria. The name was said to have been arbitrarily chosen – in Rumanian it means 'yes, yes' and in French it means 'horsie'.

DÉCOLLAGE

The act of tearing down. During the 1960s artists associated with this technique looked to street posters for material for their collages, ripping them apart and pasting the fragments onto canvases in their studio. Their aim was to reflect on the socio-economic climate of the early years after the Second World War.

DÉCOUPAGE

The art or process of decorating a surface with shapes or illustrations cut from paper, card or other items.

DIVISIONISM

This technique aimed to put the Impressionist painting of light and colour on a scientific basis by using an optical mixture of colours. Instead of mixing colours on the palette, which reduces intensity, the primary-colour components of each colour were placed separately on the canvas in tiny dabs so they would mix in the spectator's eye. Optically mixed colours move towards white, so this method gave greater luminosity. Etching: Intaglio process in which an image is created on a metal plate using acid.

ETCHING BLANKETS

Felted and tightly woven wool cloth that is cut to size to fit the bed of a printing press. The blankets help push the dampened printing paper into the grooves and lines of the etching plate.

ETCHING PRESS

Also known as a 'copperplate printing press'. The principal feature of the etching press is the sliding steel bed or plank (on which the plate lies) travelling, with direct or geared drive, between two heavy rollers. One, below the bed, supports it; the other, with adjustable screws at both ends, is directly in line above it and provides the downward pressure essential when printing intaglio plates. The bed and rollers are usually suspended on a metal frame large enough to permit the bed to be fully extended in either direction.

FOUND OBJECT

A discarded or purchased object kept for its intrinsic interest. Sometimes incorporated into a work of art, usually a collage or assemblage. May be displayed as a work of art in its own right. Futurism: Art movement launched by the Italian poet Filippo Tommaso Marinetti in 1909. The Futurists celebrated the modern world of industry and technology in the early 20th Century and used elements of Cubism and Neo-Impressionism in their paintings and collages.

GESSO

A mixture of plaster of Paris and glue. Hand roller: A tool usually made of rubber with a wooden handle, used to cover a metal printmaking plate within one full turn of the roller, widely used for intaglio and surface-colour printing.

HESSIAN

A form of canvas which generally has a coarse, thick weave.

IMPRESSIONISM

A new way of painting landscape and scenes of everyday life developed in France in the 1860s. The Impressionists' aim was to capture the fleeting nature of light on surfaces. In order to achieve this they developed a technique of brushwork involving rapid broken dabs of colour and painted outside instead of from sketches in the studio.

INKJET

A method of printing streams of electronically charged ink.

INTAGLIO

A line, cavity or textured effect, incised, scratched or corroded down into the surface of a hard substance, normally metal.

INTAGLIO PRINT

An impression made on relatively soft (damp) paper or cloth from an incised plate, usually, but not necessarily, inked.

MERZ

Nonsense word invented by the German Dada artist Kurt Schwitters to describe his collages and assemblage works based on scavenged scrap materials.

MERZBAU

Kurt Schwitters's assemblage of fragments and discarded objects which took the general form of a column that extended through several floors of his house in Hanover during the 1920s and 1930s. The house was razed to the ground during the Allied bombing raids of the Second World War, but Schwitters subsequently constructed more of these works: one in Norway which was destroyed by fire in 1951, and another in Ambleside in England, left unfinished at his death in 1947. It is now preserved in the Hatton Gallery at Newcastle University.

MEZZOTINT

A form of engraving where the metal printing plate is indented by rocking a toothed metal tool across the surface. Each pit holds ink and if printed at this stage the image would be solid black. The printmaker works from dark to light by gradually rubbing down or burnishing the rough surface to various degrees of smoothness to reduce the ink-holding capacity of areas of the plate. Mezzotint is renowned for the soft gradations of tone and richness and velvet quality of its blacks.

MIXED MEDIA

Works composed of different media. The use of mixed media began around 1912 with the Cubist constructions and collages of Pablo Picasso and Georges Braque and has become widespread as artists have developed increasingly open attitudes to the media that can be used in the production of art. Nowadays, art can be and is made of anything or any combination of things.

MONOCHROME

A painting, drawing, collage or print executed in a range of tones of a single colour.

MONOPRINT

A unique print made by printing on an unmarked surface of metal, acetate or thin perspex. Museum card: This has an acid-free surface suitable for paper collage.

NOUVEAU RÉALISME

French movement founded in 1960 by the critic Pierre Restany. *Nouveau réalistes* made extensive use of collage and assemblage, using real objects incorporated directly into the work and acknowledging a debt to the ready-mades of Marcel Duchamp.

PERSPECTIVE

Any graphic technique which creates the impression of depth and three dimensions on a

flat surface. Linear perspective is the means of creating the sensation of depth through the use of converging lines and vanishing points. Aerial perspective creates this sensation by imitating modifications of colour which occur as a result of atmospheric effects.

PHOTOSHOP
Computer software package used for image manipulation.

PICTURE PLANE
The imaginary vertical plane on which the drawing is plotted. It is, in effect, the window through which the artist views the world.

POP ART
A movement in modern art of the mid-20th Century that imitated the methods, styles and themes of popular culture and mass media, such as advertising, comic strips and science fiction.

PRIMER
A substance applied to a surface as a base sealer.

PVA
A water-based glue.

READY-MADES
Works of art that could be made from anything. Evidence of this radical idea can be seen in the work of Marcel Duchamp, a Dada artist of the 1920s who exhibited items such as a bottle rack, a bicycle wheel and a urinal.

RIPSTOP
Marine fabric from which sails are made.

SCRATCHBOARD
Surface, usually card, covered with a layer of white china clay and a black top layer of Indian ink that can be scraped away with a special tool to leave a white line

SCREENPRINTING
A stencil process in which a nylon mesh is stretched across a wood or aluminium frame. Parts of the mesh are blocked out while the image area remains as open mesh. Ink is pushed through the open mesh, using a plastic blade called a squeegee, onto paper or other material below.

SCRIM
Cotton mesh cloth used for wiping intaglio plates.

SOMERSET
A mould-made English printmaking paper.

SURREALISM
A movement in art and literature in the 1920s which developed from Dada and is characterised by the evocative juxtaposition of incongruous images so as to suggest unconscious and dream elements.

TONE
The measure of light and dark, often referred to as value.

TROMPE L'OEIL
A painting or decoration creating a convincing illusion of reality, translating from the French literally as 'trick the eye'.

BIBLIOGRAPHY

Barrett, Michael, *Intaglio Printmaking* (London: A&C Black Publishers, 2008).

Blake, Peter, *About Collage* (London: Tate Gallery Publishing Ltd, 2000).

Bonnell, Mandy and Mumberson, Stephen, *Printmaking on a Budget* (London: A&C Black Publishers, 2008).

Bradley, Fiona, *Surrealism* (London: Tate Gallery Publishing Ltd, 1997).

Chamberlain, Walter, *The Thames and Hudson Manual of Etching and Engraving*. (London: Thames and Hudson Ltd, 1972).

Cottington, David, *Cubism* (London: Tate Gallery Publishing Ltd, 1998).

Cox, Neil, *Cubism* (London: Phaidon Press Ltd, 2000).

De Reyna, Rudy, *How to Draw What You See* (New York: Watson-Guptill Publications, 1996).

Gale, Colin, *Practical printmaking* (London: A&C Black Publishers, 2009).

Gombrich, E.H., *The Story of Art*, 13th edn (Oxford: Phaidon Press Ltd, 1995).

Gooding, Mel, Sandra Blow, *Space and Matter* (Cornwall: Tate St Ives, 2001).

Goya, Francisco, *Great Goya Etchings* (Mineola, NY: Dover Publications Inc., 2006).

Kaufman, Elizabeth Elias, *Cézanne* (Baltimore, MD: Ottenheimer Publishers Inc., 1980).

King, J., *Interior Landscapes: A Life of Paul Nash* (London: Weidenfield and Nicolson, 1987).

Lumley, Robert, *Arte Povera* (London: Tate Publishing Ltd, 2004).

Manie, Ann, *Collage in the Classroom* (London: A&C Black, 2008).

Mayer, Ralph, *The Artists' Handbook of Materials & Techniques*, 5th edn (London & Boston: Faber and Faber, 1991).

Poggi, Christine, *In Defiance of Painting: Cubism, Futurism and the Invention of Collage* (New Haven: Yale University Press, 1993).

Rembrandt Drawings (Mineola, NY: Dover Publications Inc., 2007).

The Complete Etchings of Rembrandt (Mineola, NY: Dover Publications, 1995).

Saxton, Colin, *Art School: An instructional guide based on the teaching of leading art colleges* (London and Basingstoke, QED Publishing/ Papermac, 1982).

Schmalenbach, Werner, *Kurt Schwitters* (London: Thames and Hudson Ltd, 1970).

Schulz, Isabel, *Kurt Schwitters: Color and Collage* (New Haven and London: The Menil Collection, distributed by Yale University Press, 2010).

Scott, Marilyn, *The Drawing Bible* (Tunbridge Wells: Search Press Ltd, 2005).

Taylor, Brandon, *Collage: The Making of Modern Art* (New York: Thames & Hudson Inc., 2004).

Thomas, Denis, *The Age of the Impressionists* (Twickenham: Hamlyn Publishing Group Ltd, 1987).

Wilson, Simon and Lack, Jessica, *The Tate Guide to Modern Art Terms* (London: Tate Publishing Ltd, 2008).

INDEX

Arp, Hans 16–17
assemblage 20–1, 77–8
Ave, Fereydoun 36–8

Becker, Polly 39–41
black and white tonal collage 88–90
Blake, Peter 26–7
Blow, Sandra 32–5, 70
Boccioni, Umberto 13–14
Braque, Georges 11–12

chine collé 47, 94–105
coloured collage 91–2
composition 86–7
conservation 93
Constructivism 18
cropping 87
Cubism 11–14, 18–20, 23, 58, 70, 87

Dada 15–19, 56
décollage 26
Devereux, Zara 42–3
Divisionism 13–14
Duchamp, Marcel 15

Emin, Tracy 21
Ernst, Max 16–17

found object 18–21, 78
framing 93
Frost, Anthony 44–6
Futurists 13–14, 18

glue 89, 93

Hamilton, Richard 23–4
Hausmann, Raoul 15, 17
Hicklin, Jason 47–9, 94–9

Kanso, Nadine 50–1

Long, Denny 52–3

Malallah, Hanaa 54–6
Manie, Ann 57–64, 100–5
materials 88, 91, 93
Matisse, Henri 93
monochrome 88

Nouveau réalisme 26, 71

Ofili, Chris 26–7

Paolozzi, Eduardo 22–3
perspective 11
photographic images 72–3, 90
Photoshop 36
Picasso, Pablo 11–12, 18, 93
Pop art 22–5
projects 108–19

Rauschenberg, Robert 24–5, 81
Ray, Roy 65–9
recycling 79
Rudge-Litten, Angela 70–1

Sabella, Steve 72–4
Saifan, Fatma 74–5
Salim, Rashad 76–8
Schwitters, Kurt 19–21, 78
'sealing' 93
storage 93
Surrealism 15–18, 58

tone 89–90

viewing frame 86

Williams, Tamsyn 79–81